DRAW

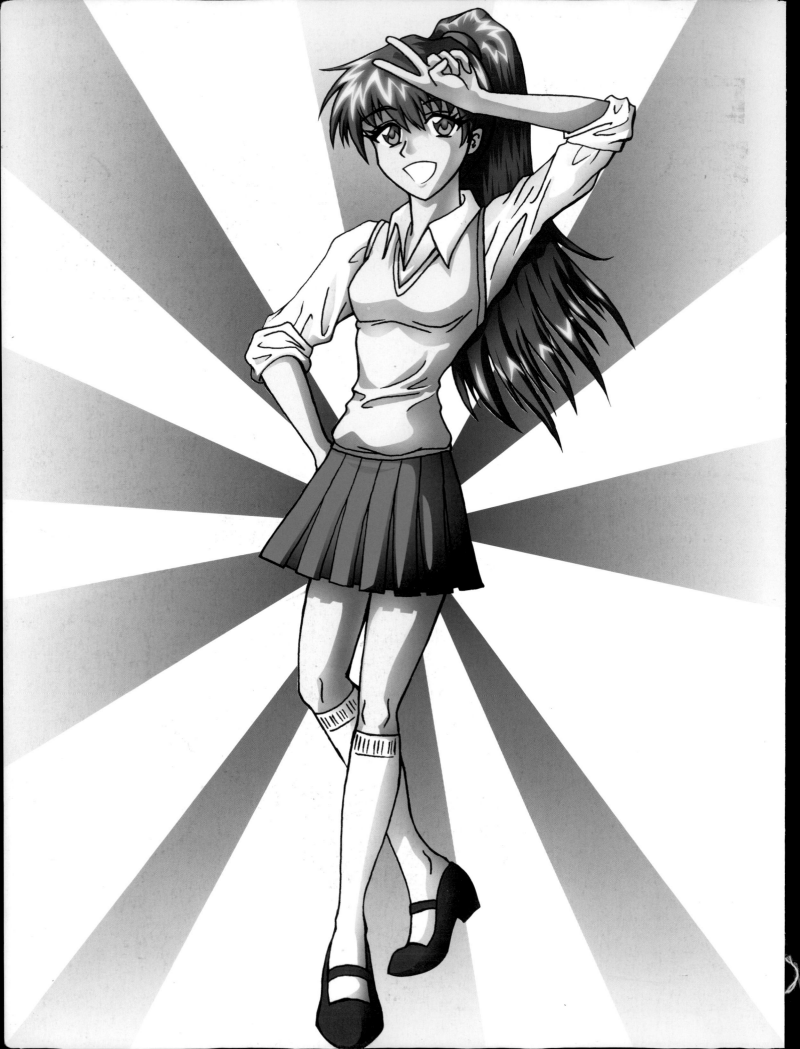

DRAW MANGA

Sweatdrop Studios

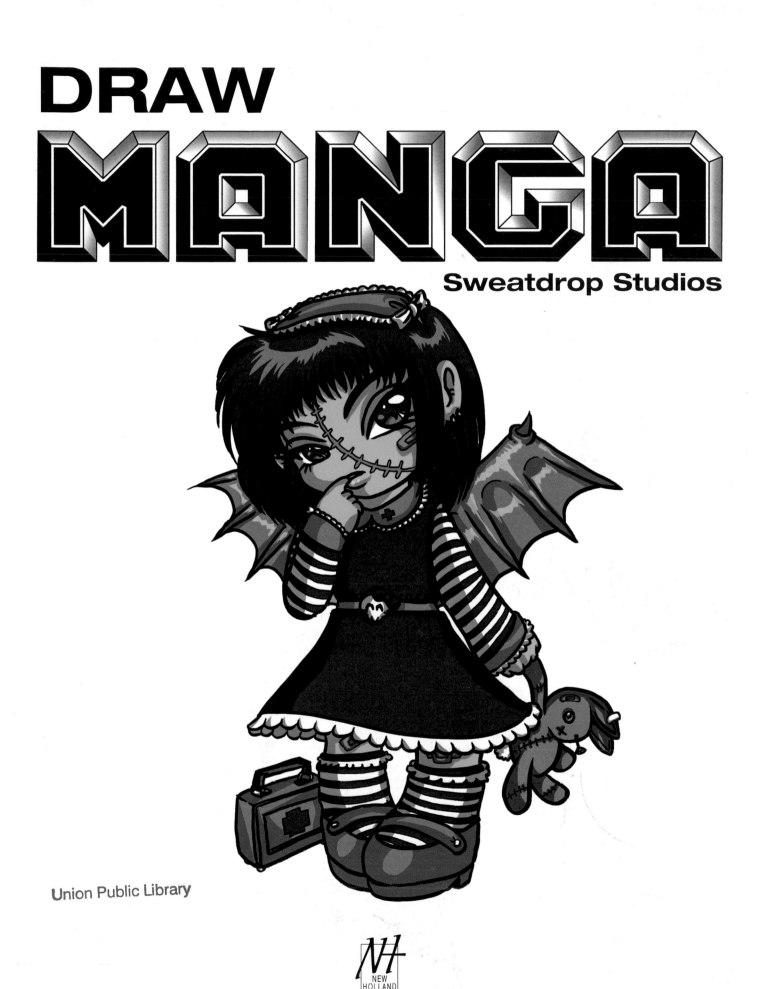

NH
NEW
HOLLAND

First published in 2006 by
New Holland Publishers (UK) Ltd
London • Cape Town • Sydney • Auckland

Garfield House, 86–88 Edgware Road
London W2 2EA
www.newhollandpublishers.com

80 McKenzie Street, Cape Town 8001
South Africa

14 Aquatic Drive, Frenchs Forest, NSW 2086
Australia

218 Lake Road, Northcote, Auckland
New Zealand

ISBN 13: 978 1 84537 416 7
ISBN 10: 1 84537 416 9

Senior editor: Clare Hubbard
Designer: Adam Morris
Production: Hazel Kirkman
Editorial direction: Rosemary Wilkinson

Reproduction by Pica Digital Pte Ltd, Singapore
Printed and bound in Malaysia by Times Offset
(M) Sdn Bhd

10 9 8 7 6 5 4 3 2 1

Contributors

Head Contributors

Sonia Leong – Sweatdrop Editor
Introduction; Tutorials: Head, Figures and
Proportion, Action Lines and Poses, Clothing;
Step-by-Step Creation: Male Child Alternative 1,
Teenage Female; Projects from the Masters:
Coloured Markers

Selina Dean
Tools and Equipment; Tutorials: Faces and
Expressions, Figures (Exaggerated Proportion
Sets), Action Line examples, Clothing example,
Accessories, Chibis/Super-deformed Characters;
Step-by-Step Creation: Female Child, Teenage
Male Alternative 2; Projects from the Masters:
Watercolours, Coloured Pencils Alternative

Hayden Scott-Baron
Tutorials: Action Lines and Poses examples,
Clothing example, Lighting, Colour Theory; Step-
by-Step Creation: Teenage Male, Adult Male
Alternative 2, Adult Female Alternative 2; Projects
from the Masters: Pen and Ink

Laura Watton
Tutorials: Hair, Hands and Feet, Clothing
examples, Accessories examples; Step-by-Step
Creation: Alternative Female Child 2, Adult Female;
Projects from the Masters: Watercolours
Alternative, Coloured Pencils

Emma Vieceli
Tutorials: Eyes, Interaction, Clothing examples;
Step-by-Step Creation: Male Child, Teenage
Female Alternative 2, Adult Male; Projects from the
Masters: Pen and Ink Alternative

Other Contributors

Sam Brown – Adult Female Alternative 1
Carrie Dean – Teenage Female Alternative 1
Niki Hunter – Adult Male Alternative 1
Aleister Kelman – Teenage Male Alternative 1
Morag Lewis – Female Child Alternative 1
Wing Yun Man – Male Child Alternative 2

CONTENTS

Introduction

"Manga" is a word which is becoming well known throughout the world. Literally, it is the Japanese word for comics. But "comics" is not an adequate description of what manga truly is. Manga encompasses all story genres – not only are there action-adventures, as in the majority of Western comics, but there are romances, instructional booklets and soap opera dramas. Manga can be aimed at all audiences, from schoolboys to housewives. Sequential art from Japan and East Asia has developed many forms of expression, style and dynamism – so much so, that it has become an art form in itself.

This book will teach you how to draw in this unique comic style. While there are myriad ways to depict a character depending on the story and the audience, there are certain ways of drawing which stand out as being quintessentially manga. Large, expressive eyes are among the top traits. Another would be voluminous, shiny hair. Exaggerated proportions and facial expressions are also widely used. This book will teach you the basics of the art form, while providing many examples of different styles and interpretations.

Sweatdrop Studios is the UK's leading comic collaborative group producing original comics and illustrations in the manga style. Founded in 2002, our members have been fans of the art form for many years, producing over 80 titles and several anthologies. We are enthusiastic about manga and its moving counterpart anime (Japanese animation), and hope that more people will learn about and appreciate the beauty and energy behind the art.

This book is for beginners of all ages. While younger readers will be able to follow the visual cues, more mature readers may gain from reading our accompanying text more thoroughly as we point out tricky areas of the drawings to consider and offer handy tips – a real opportunity for you to get inside the mind of the artist.

The book is organized into three sections, progressing from the absolute basics of drawing a manga character through to creating polished

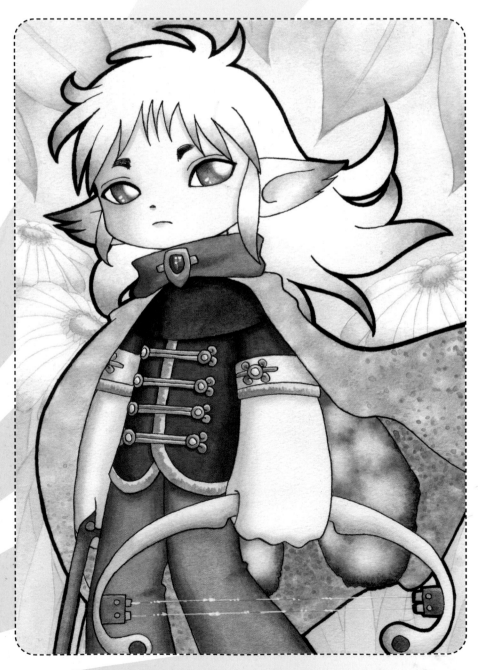

pieces of art in various mediums. The first section, Tutorials (see pages 10–43), teaches you how to create a manga character from scratch – from figure work and anatomy, through to accessorizing and colouring. The second section is called Step-by-step Creation (see pages 44–79) – here we cover the popular characters in the world of manga and anime, teaching you how to create a particular character in incremental steps and offering different interpretations. The book finishes with Projects from the Masters (see pages 80–95), where we take you

through the process of creating professional-standard manga artwork using watercolour, colour pencils, colour markers and inks.

Once you've learnt the basic skills, really use your imagination and try drawing your own characters. Perhaps you could go on to create your own manga story, produce a comic or even an animation. We hope that this book inspires you to practise and develop your own innovative style. Now, let's draw Manga!

Tools and Equipment

Every artist has to start somewhere, and that somewhere is usually choosing the right tools and materials to draw with. No matter what your experience level, selecting the appropriate media and good quality tools is essential to achieving the best results.

Drawing Tools

Pencil

A pencil is the most essential tool for drawing. For illustration, hard leads (H onwards), are best as they don't smudge under the normal hand movements you make while drawing. Many artists use mechanical pencils, enabling them to draw constantly without having to stop to sharpen the pencil.

Erasers

There are two types of eraser: plastic and putty/kneaded. Plastic erasers come in a variety of shapes and sizes, and are best for general use. Putty erasers are soft, and can be kneaded into different shapes, making them great for erasing small mistakes or adding detailed highlights to pencil drawings.

Fineliners

Fineliners are pens with small plastic tips, used for technical drawing or illustration. They give a flat, consistent line and come in a variety of nib sizes. Most fineliners are disposable, but there are some more expensive brands available which are refillable, and give you more choice over the ink you use in them. Fineliners are the easiest pens to ink with.

Dip pens

Dip pens are the traditional tool for inking. They have great flexibility and variation in the lines they produce, and you can use a huge range of different inks with them. However, they are messy, not easily portable and it takes a bit of practice to learn to control the pressure on the nib properly. Nibs need frequent cleaning while working, and replacing regularly.

Brush pens

A modern alternative to inking with a brush, brush pens are easy and clean to use. Fibre-tipped brush pens are cheap, firm and easy to control, but are disposable. If you want something almost exactly like a brush, there are more expensive types with bristle tips. These usually take refill cartridges, but will still wear out eventually as the bristles can split or fray.

Colouring Tools

Brushes

When choosing brushes, make sure they're suitable for the medium you're using. Soft brushes are best for inks and watercolours, coarse brushes for acrylic and oil paints. Avoid really cheap brushes and brushes that have split tips.

Coloured pencils

Coloured pencils are cheap and come in a wide range of colours and types (like watercolour pencils or chalk pastel pencils). They are easy to use, but can be time consuming when working on large drawings. Often they work best when used to supplement other media.

Watercolours

Watercolour is a water-soluble paint that comes in tubes or solid in pans. It can produce a range of effects, but needs time and practice to master. It is a cheap, easily obtainable medium used by many illustrators.

Markers

Favoured by many manga artists, markers offer great permanence and consistency of colour. Alcohol-based markers are easier to use and give better results than water-based ones, but are also more expensive. Markers are portable and quick to colour with, but it requires huge investment to get a large enough range of colours to make the most of your work.

Screentone

Screentone is used to add shading to comic pages and black and white illustrations. The majority of tones available are simple 'halftone' dot patterns, but there are many more abstract patterns available, and even coloured tones. Screentones are self-adhesive and are applied by cutting out the shapes required with a knife, and pressing them firmly onto the illustration.

Computers

Computers are used by both professionals and amateurs to create pristine-looking illustrations. Many people work with a graphics tablet: a pressure-sensitive digital pen you use on a special location-sensitive tablet. This gives artists great control despite working with an intangible digital media. There are many types of software that give different results.

Tutorial: Head

Although manga is a very distinct form of artwork, it is based on the fundamental skills of basic figure-drawing and knowledge of anatomy. Too often many beginners launch straight into the more famous aspects of the manga style, such as the exaggerated facial features and the lustrous hair, and upon completing their drawing realize that something does not look quite right. It is very important to have some knowledge about how the overall head of a character is put together, as it forms the "canvas" for the face, allowing you to place facial features accurately. Knowing how to construct a head from first principles will mean that you can effectively portray a character from almost any angle. The human head comes in many different sizes and shapes. However, all heads are formed from a skull, which can essentially be represented by a sphere with a lower jaw.

Building Blocks

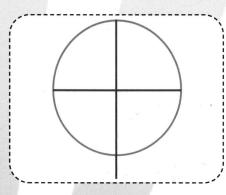 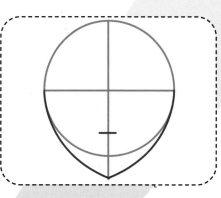 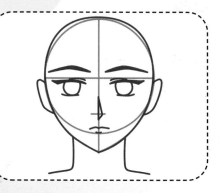

1 Draw a circle for the upper part of the head. Draw a cross over it, splitting the circle into quarters. The vertical line represents the centre line of the head and face. The horizontal line represents the upper eye-socket line.

2 Draw curved lines from the sides of the face to the bottom of the vertical line. These lines map out the chin and jaw. Draw another horizontal line in between the eye line and the point of the chin, roughly equidistant from the two. This helps place the nose.

3 Using these lines as a rough guide for the placement of features, add in the details of the eyes, nose, ears, mouth and neck. The ears are at a similar level to the eyes and are spaced evenly on the sides of the head. The mouth is approximately halfway between the bottom of the nose and the chin.

Useful Tips

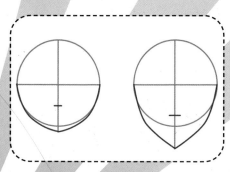

Note that the strength and length of the curve can vary for different faces, depending on how far you extend the vertical centre line.

These guidelines are intended as a rough way of placing facial features. Depending on the type of character you are drawing, their features can extend beyond these lines.

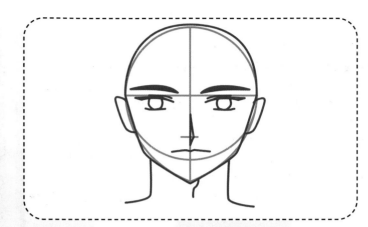

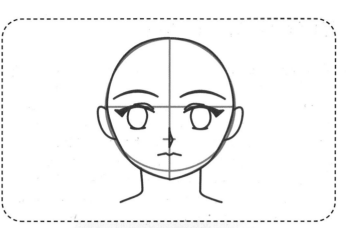

For a male face make the neck thicker, eyes narrower, nose longer and the jawline more angular. Don't forget the Adam's apple!

When drawing a child, the lower half of the head is more compact making all the facial features much closer together. Draw a small, short nose and mouth, but keep the eyes large, as in real life. This conveys a sense of cuteness.

Different Views

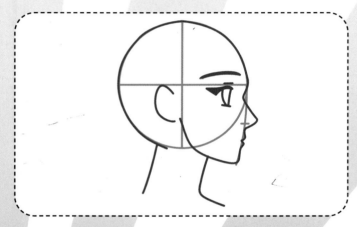

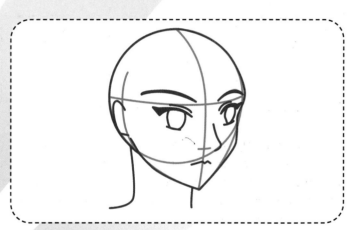

To draw a side view, start with the forehead, then dip in slightly before drawing the nose. Below the nose, draw another dip into the lips, then chin. Note how the lips and chin are not far from the face's centre line. Also observe the placing of the ear, slightly closer to the back of the head than exactly halfway.

Three-quarter views benefit most from guidelines – think in three dimensions when drawing the centre line and eye line. Take care with the side of the face – draw a slight dip below the temple, rounding out to the cheekbone. The jawline can then be round, sunken, muscular, etc. as appropriate.

Over To You! ▶

Here are various examples of different characters' heads from several viewpoints. These characters do not have the same facial proportions as they range from male to female, young to old. By using the basic model you can ensure all of their features are realistically placed at every angle the head is viewed from.

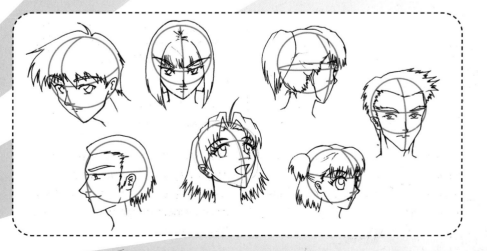

Tutorial: Eyes

Large eyes are the most iconic feature of the manga aesthetic. However, there are many different approaches to drawing manga-style eyes and each approach can radically change the way in which a character is perceived. Manga is all about individuality, so use the following guidance as stepping-stones to developing your own unique style.

Building Blocks ▶

On the two-dimensional plane, an eye is made up of three sections: the upper line, the ball and the lower line. These three simple parts can be moulded into an infinite number of unique styles. Two very different examples are shown below.

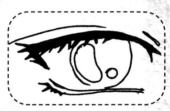

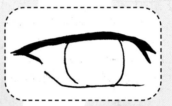

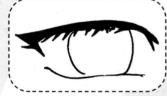

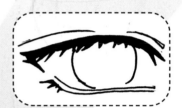

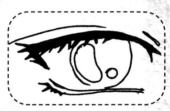

The upper and lower lines are elongated and flattened. An outside corner has been added and the two lines are almost touching. This makes the whole eye fairly closed in. The ball is partly obscured by the upper line as if to suggest a slightly hooded or glazed expression.

The upper lashes are curving down into the eye rather than upwards as expected. This closes the eye in further.

A double line has been added inside the lower line to give a slightly three-dimensional perspective. A couple of extra lines have also been added above the eye to show the eyelid and even the start of the bridge of the nose.

Finally, a light source is added to increase the glazed look. The overall impression is of a closed and mysterious character.

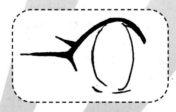

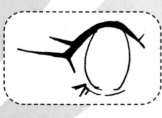

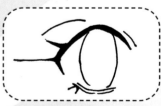

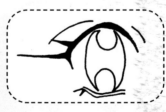

The upper line is arched rather than flattened and the lower line shortened. There is still an outside corner, but this time the two lines are further apart. The ball has been expanded upward and is fully visible.

A large and simple lash has been added to this eye, rather than the complex lashes of the first example.

The double lines are still in place.

This time two simple light spots have been chosen. The impression here is one of wide-eyed wonder and brightness.

Side View ▶

When drawing an eye in profile, remember that the upper and lower lines originate from the outer corners of the eye.

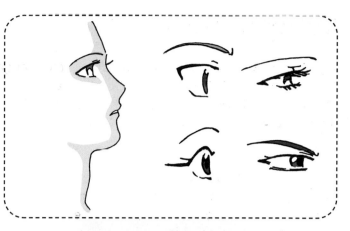

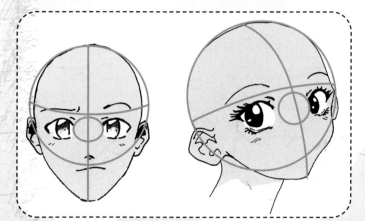

◀ Positioning

As a general rule, when positioning eyes on a head they are placed in line with the ears, halfway down the head – (see step 1, page 10). A simple rule of thumb for distancing the eyes from each other in a straight-on view is to imagine an invisible third eye in the centre. When drawn in a three-quarter position, the eye furthest from the viewer will seem slightly smaller, partly covered by the bridge of the nose.

Light Source and Colour

As an additional touch, colour and light are distinctive features of manga. Eyes offer the opportunity to go crazy with them – almost anything goes!

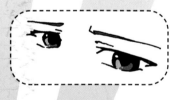

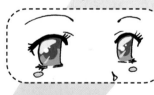

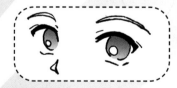

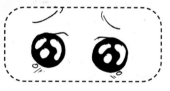

Large black pupils curl right around the iris. There is only a small light spot in each eye.

The large pupils have been coloured a slightly darker shade than the iris, rather than traditional black. These large eyes reflect a lot of light back!

A gradient fill (a colour fill that gradually blends) has been used – no pupil is visible at all.

An extreme amount of light spots has been added to accentuate the openness of the eyes and the upper and lower lines have been dispensed with. This is all done for comic effect.

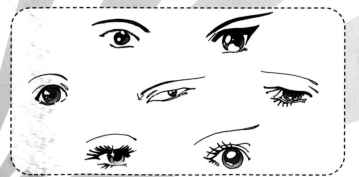

◀ Over To You!

Armed with the basic foundations of shape, build, positioning and light, it is time to see what you can create! Within the boundaries of the rules of thumb that we've given you it is possible to create a vast array of different eyes – some examples are shown left. Each one is simply a variation on our three-part eye. Can you spot what has been done to each section? What kind of characters would have eyes like these?

Tutorial: Faces and Expressions

On the most basic level, manga-style faces look very similar: they generally have tiny noses and huge eyes. But beyond the obvious similarities, there are many subtle nuances that you can use to build a unique style and individual characters.

Expressions

An important aspect of achieving a genuine manga look with your characters is stylizing their expressions correctly. Many characters will have a set of common expressions, depending on their attitude and personality. For example, shy or stoic characters won't be seen with overly exaggerated expressions. Likewise, a happy or comedic character will lose their impact if you give them subtle features. Think about your character's personality and what kind of faces they would pull! Some examples are shown below.

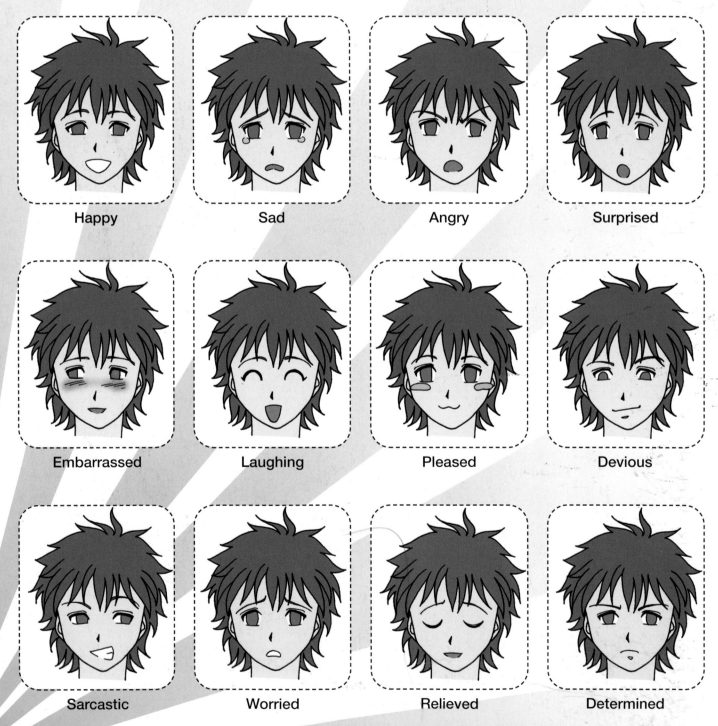

| Happy | Sad | Angry | Surprised |

| Embarrassed | Laughing | Pleased | Devious |

| Sarcastic | Worried | Relieved | Determined |

Eyes and Eyebrows

A lot of the emotion of a character is shown in the eyes and eyebrows. Even slight changes to the angle of the eyebrows can create a different expression.

Visual Grammar and Exaggerated Expressions

"Visual grammar" is a kind of illustrator's shorthand; iconic images used to quickly create a mood or just for comedic exaggeration. Here are some examples of visual grammar used to enhance characters' expressions, but be careful not to overuse them. These kinds of exaggerated expressions can look great in humorous or light-hearted drawings, but would be very inappropriate in serious or dramatic images.

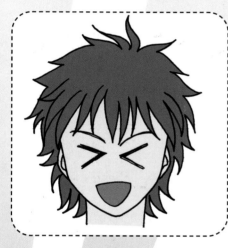

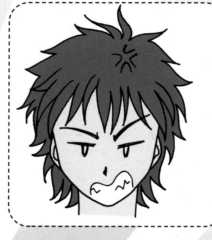

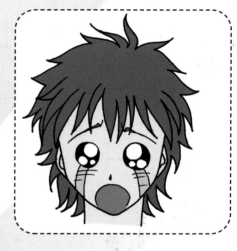

Happy – with eyes clasped shut and a huge grin. This is a very silly expression.

Angry – the throbbing vein on the character's head is a sign of anger.

Sad – large, wet eyes and rivers of tears are usually a trademark of cuter characters.

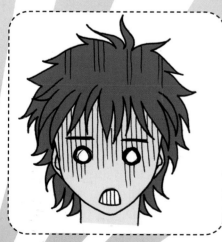

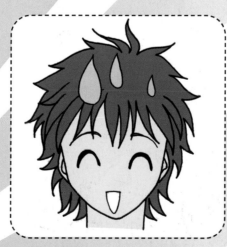

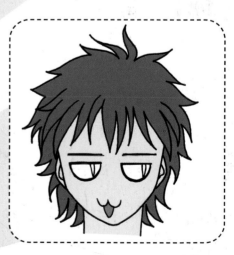

Shocked – the lines on the character's face give it a gloomy, doomed look.

Embarrassed – large drops of sweat often appear above a character's head when they're embarrassed or exasperated.

Mischevious – the cat-like eyes and mouth make the character look sneaky and cunning.

Tutorial: Hair

Manga characters have very distinctive and brightly-coloured hair. Their hair is noticeably of a different shape and style to their Western counterparts and the varying colours used on manga characters' hair helps differentiate each character from their peers. Hair is very expressive; many aspects of real-life hair – such as the flow, the gravity, the lift and volume – are better represented in a three-dimensional style through adding details such as lines, shadows and highlights.

Placement of Hair on the Head

It is important to put a few rules into practice when it comes to drawing manga-style hair to prevent the shape of the head from appearing incorrect and the hairstyle from looking amateur. Hair is often divided into chunky strands which taper off to a point. Try to draw with a flowing motion and make sure the points all meet up to close the lines. All hair grows from a central point. Think about how your own hair grows, where your hair falls to one side, where your parting is and try applying it to your characters for added realism.

◄ Look at these two examples. Make sure that the head is constructed correctly (see Head on pages 10–11). The construction lines for the head are mapped out in light blue. The green lines depict an outer shell surrounding the characters' heads. This is where the bulk of the hair will rest on top of the head. Roughly speaking, there should always be an equal amount of space between the outline of the skull and the "boundary" of the hair.

The red lines mark out what you should try to avoid, namely:
• Drawing hair that is not proportional to the skull outline.
• Drawing hair too thickly or thinly on one side – this makes the skull look misshapen.
• Drawing spikes which are not fluid or not defined by points at their ends and roots.

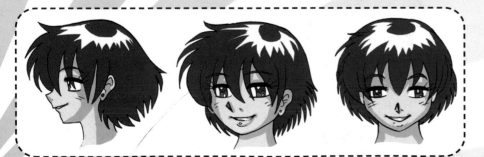

◄ Here are several views of the same character so you can see how her hairstyle looks from various angles.

Different Styles for Different Characters

Consistency of hair matters; if a character has thin hair, they could have a meeker personality. Thicker, chunkier hair suggests a more energetic nature. Sleek and straight suggests a fashion model whereas messy hair is a sign of a more creative or active profession. The colour of manga hair can be any shade of the rainbow! But your choice must say something about your character. If a character has bright pink hair she may be a very energetic, young girl. If a character has white hair he may be spiritual or even very old! Make really modern manga characters by looking at what hairstyles are popular right now – try looking at hairstyle magazines.

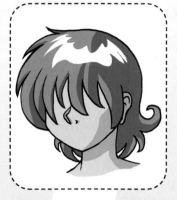 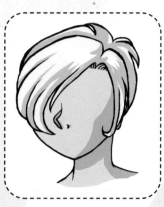 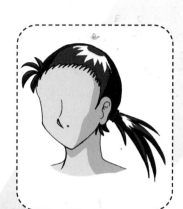 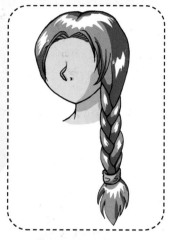

If your female character has short hair, she could be very sporty or tomboyish.

Here's another example of a short hairstyle that your character could have.

Hair that is closely shaven or very tightly tied back can be drawn closer to the skull.

Drawing plaits is quite difficult. Try creating your own three-dimensional model from modelling clay to use as reference.

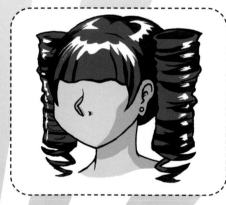 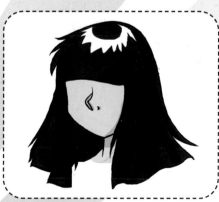

◀ Would a fringe make your character look serious? Is every strand of hair the same length? Does your character's hair flow outward in a triangular fashion or is it quite sleek and layered?

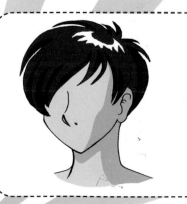

Tutorial: Figures and Proportion

All of these studies are of the same male and female character shown at different ages. The ratios described are relative to the head length and width of the character, so this information is easily transferable to whatever size you wish to draw your characters. These simple ratios are a rough guide to real proportions. To help you with your observations, equally spaced lines (roughly one head length apart) have been drawn behind the characters.

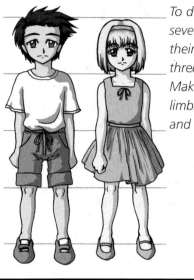

To draw children under seven years of age, bring their height down to three–four head lengths. Make their cheeks and limbs more chubby and rounded.

Children

These are children in the seven–twelve years age bracket; the most popular age group of children depicted in anime and manga.

Height: 4–5 head lengths
Shoulder width: 2 head widths and under
Torso length: 2 head lengths
Waist width: 1–2 head widths
Hip width: 1.5 head widths
Leg length: 2–3 head lengths

Children do not have greatly defined muscle tone. Their frames are not fully developed, so their shoulders are still quite narrow. Their faces are short and round, with large eyes. Note there are already differences between the sexes – boys have longer torsos and a straight section at their waist, girls have higher, slightly pinched-in waists.

Once you have marked out the correct ratios with some rough lines, to build up the bulk of the body you may find it useful to use circles and ovals to remind you of how joints work and of the mechanics of the body. Note the following observations:

- *The elbow joint is situated at waist level.*
- *The hand should reach halfway down the thigh.*
- *There is a small gap between the thighs where they join to the hips.*
- *A male waistline is a cylindrical band with straight sides.*
- *A female waistline is pinched-in. The narrowest section can be defined by a simple line.*

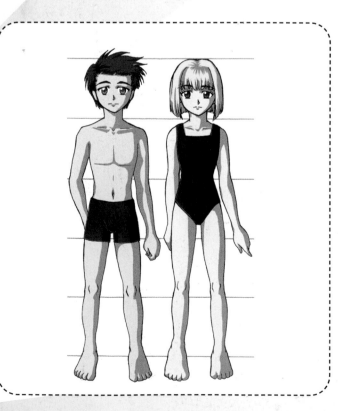

Teenagers

The characters are now between 13–17 years old. This age group can vary greatly in proportion set across different manga stories. This example could even be used for petite adults.

Height: 5–6 head lengths
Shoulder width: 2 head widths
Torso length: 2–3 head lengths
Waist width: 1–2 head widths
Hip width: 1.5 head widths
Leg length: 3 head lengths

Although this is dependent on whether your characters go through a gangly or chubby adolescence, in general, more muscle and bone structure should be visible. This applies to both the face and figure. For males, shoulders are broader and the ribcage wider which helps define the straight waist. For females, the hips are a little wider and breasts start to show.

Adults

These are fully developed adults in their twenties–thirties. In this example the adults are quite tall and slim.

Height: 7–8 head lengths
Shoulder width: 2–3 head widths
Torso length: 2–3 head lengths
Waist width: 1–2 head widths
Hip width: 1.5–3 head widths
Leg length: 4 head lengths

Full muscle and bone structure has developed. Males have broad shoulders. The straight section of the waist is plainly visible now, leading into fairly slim hips, only slightly wider than the waist. Females have medium-width shoulders, full breasts, curving into a pinched-in waist, then widening into large hips, roughly the same width as the shoulders. Relatively speaking, men will have longer torsos and women will have longer legs.

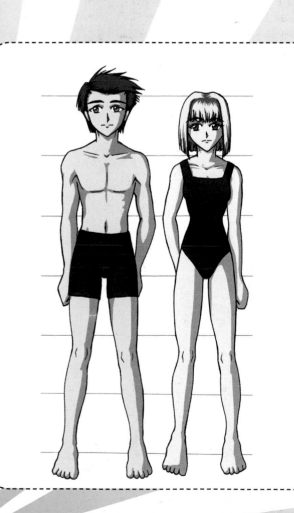

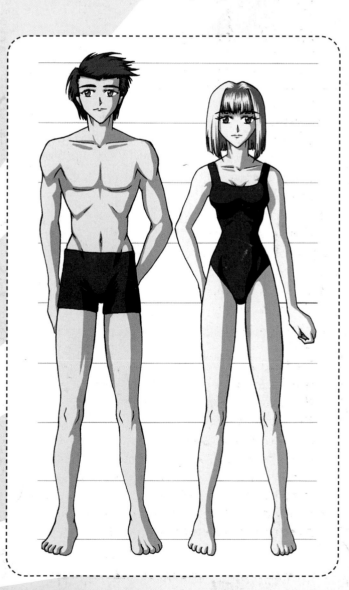

Exaggerated Proportion Sets

The world of manga art is filled with many genres, from gritty realism to light-hearted slapstick. Therefore, the style of drawing changes to match the atmosphere of the story. Once you have the foundations for correct human proportions, try out these different styles on your characters.

Chibi

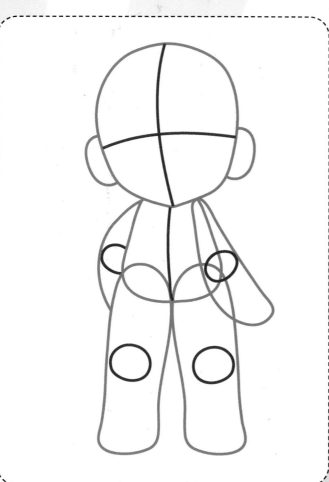

Cartoon

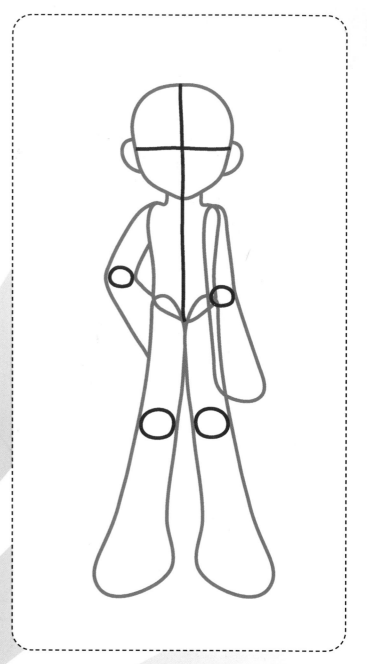

The most common form of exaggeration across all manga is to draw very cute, miniature versions of characters with very large heads (barely three head lengths tall) and squished, chubby bodies (in order to support the heads). This is "chibi", Japanese for "tiny", although the direct translation is slightly more like "titchy" or "little squirt". This style is not usually maintained throughout an entire comic book or animation because it is so extreme – characters tend to slip into this look at various points in the story when something funny happens. This style is so prevalent in manga that there is a section devoted entirely to it on pages 42–43.

This proportion set is used across many themes, but it all comes down to a general look of cuteness. This style has a chibi feel to it, but is not as extreme. Often seen in manga aimed at younger readers, the characters look fun and funky, with fairly large heads so their features are clear to see, small torsos and limbs, but oversized hands and feet.

Shoujo

Shonen

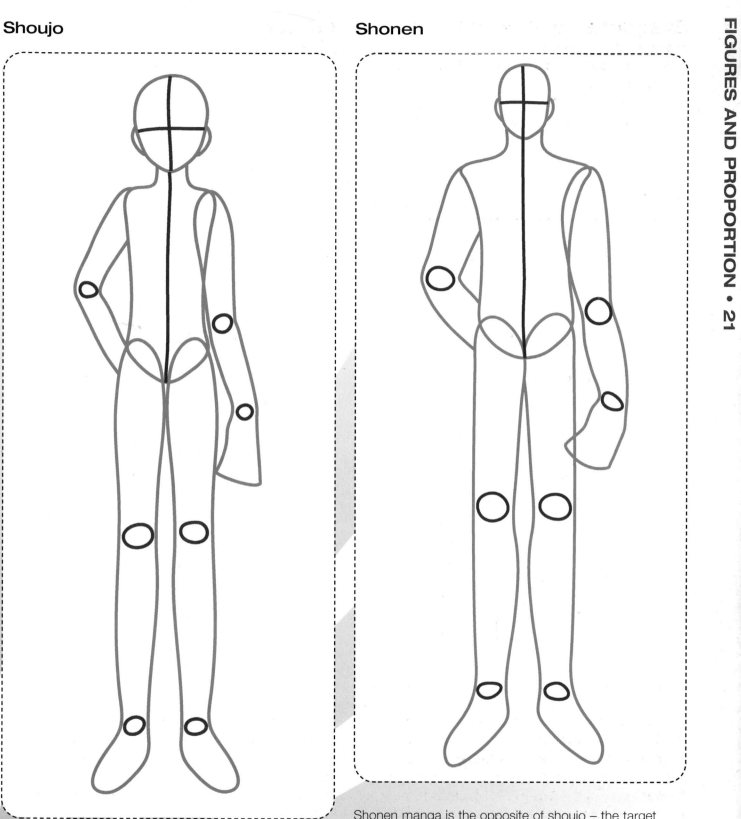

Shoujo manga are comics aimed primarily at girls and young women. The characters are usually very beautiful and engaged in emotional storylines. Therefore the shoujo proportion set is very slim overall to complement the delicate characters, while the head remains its original size so it can hold expressive faces with large eyes.

Shonen manga is the opposite of shoujo – the target audience is men and boys – it features action-packed stories with explosions, martial arts, or sexy women. Characters' proportions become heroic, very tall (around 10 head lengths) and are strongly built. The most popular heroes of shonen manga tend to wear cool costumes and carry outrageous weapons, so the focus is taken away from the head and face.

Tutorial: Hands and Feet

Drawing hands and feet may seem a little tricky at first, but it's important to depict hands and feet accurately. The good news is that this can be done quite simply.

How to Construct a Hand

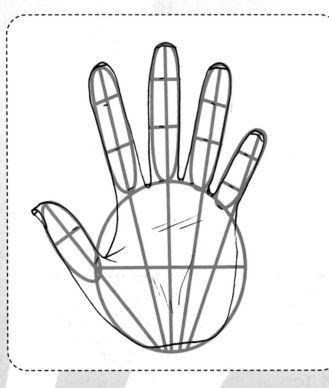

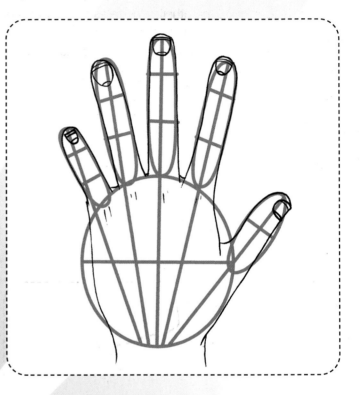

Underside of a left hand ▲

Draw an oval, then draw over a cross – this forms the palm of the hand. Extend the middle line upwards as tall as the palm, then draw two guidelines on the right and on the left of the middle, all slightly splayed out, originating from the bottom of the palm.

The thumb is at a deeper angle and is a shorter, yet rounder, part of anatomy.

Draw a long bubble that is almost the length of the oval. This will be the longest digit. Continue to draw long, oval bubbles, taking care to make sure the left digit is almost as high as the middle digit.

The third digit is slightly smaller than the second and the little finger only reaches up to two-thirds of the length of the third digit.

Each finger is divided into three sections; the thumb, two. On a female, the tips of her fingernails may also be showing from this angle.

Back view of a hand ▲

Follow the guidelines as detailed left, but the digits will be in reverse order when depicting the same hand. Take note of details such as knuckles and fingernails.

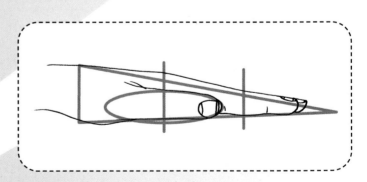

Side view of a hand ▲

Draw a thin and long triangle shape, with one edge angled higher than the other. Divide it up into thirds. Draw a long balloon on the first division – this will be the thumb and the division is the thumb knuckle. Note how the thumb joins the hand and the folds of skin that depict this.

How to Construct a Foot

Underside of a right foot ▶

Draw a circle and an oval that align vertically. Draw a curved line through the bottom of the oval. Join the edges of the circle and oval. Now draw five ovals hovering above the oval, these will be the toes. The big toe will be quite large in proportion to the others. The tallest toe will be the second toe, with the remaining three toes dropping in height as well as proportion. Join the toes to the foot with small inward-curving lines.

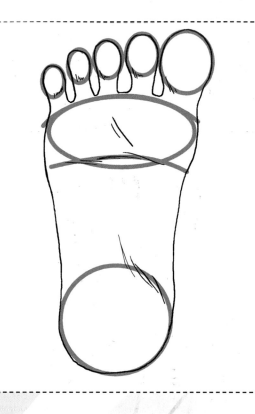

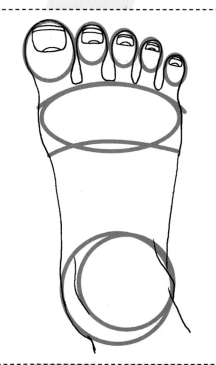

◀ Top of a right foot

Follow the detailed guidelines above, but the digits will be in reverse order. Draw toenails at the very tips of the toes, with the large toenail being much bigger than the others. The ankle is slightly visible, so draw another circle above the heel and slightly to the outside of the foot.

Side view of a foot ▶

Draw three circles – medium for ankle, large for heel and small for ball of the foot. Draw a smaller oval to depict the big toe. Join these circles with inward-curving lines and create the bottom of the characters' leg from the large circle.

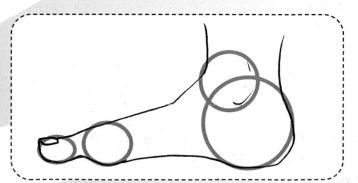

Adapting to different characters

Some aspects of these drawings will have to be changed to suit your character, depending on their gender, their size, their age, and so on.

◀ ▼ Adult hands and feet are slightly more detailed to show signs of age and wisdom. Elderly characters will have very withered hands.

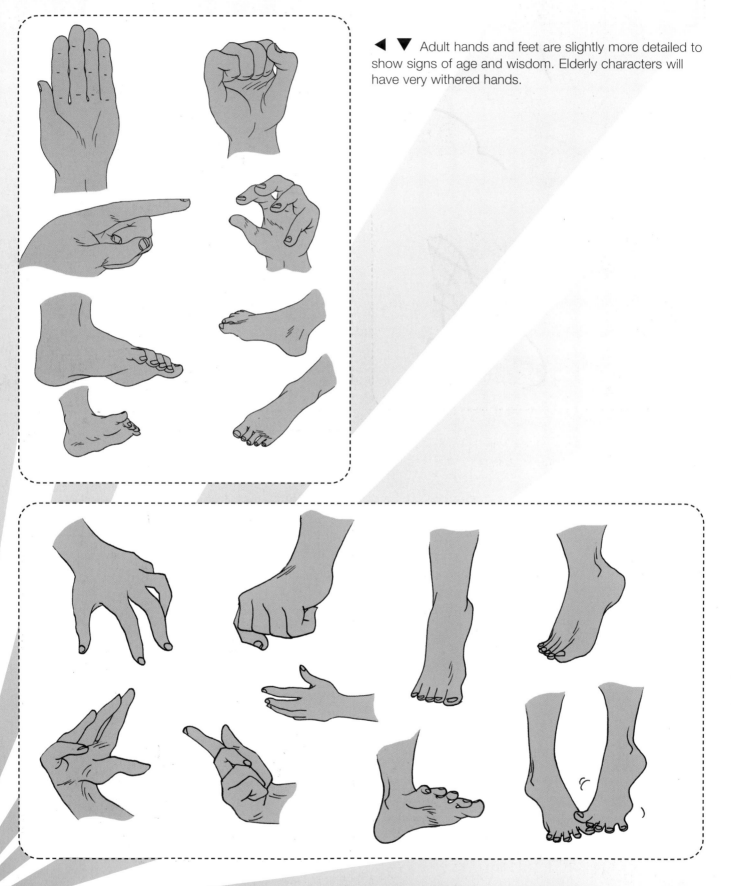

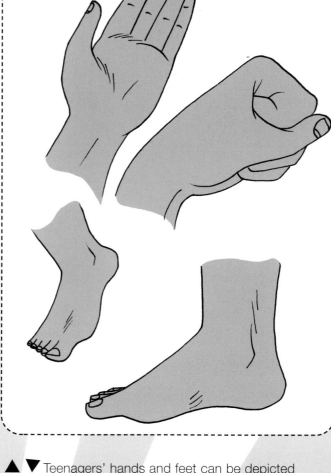

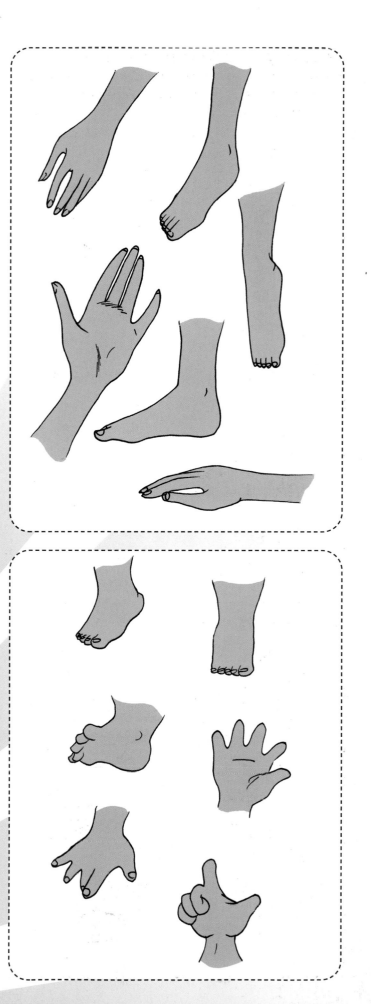

▲▼ Teenagers' hands and feet can be depicted simply, to portray beauty and youthfulness.

▶ Childrens' hands and feet have cuter, stubbier proportions.

Tutorial: Action Lines and Poses

Also referred to as the line of movement, the action line of a drawing represents the driving force behind the illustration, defining the layout and structure. It is the hidden spine of an image, possibly the curve of a pathway in a photograph or the run of a river in a landscape painting. Similarly, action lines can be applied to your manga characters to add a sense of dynamism and flow. It is a useful tool for drawing both active and static poses.

Shaping Up

Draw a curved line on a piece of paper. Now imagine a person assuming that shape. Action lines map out the overall shape of a character's pose, providing a guideline for the body to follow. Here's an alternative way of thinking about it – if you could only make one brush stroke to explain to someone the pose your character is in, what would it be?

Action lines generally start from the character's head and end just below the torso. Most importantly, the action line must mark out the character's spine – think of it as a string that goes right through the centre of a puppet from top to bottom. Observe how the action line extends beyond the spine in the two examples shown below.

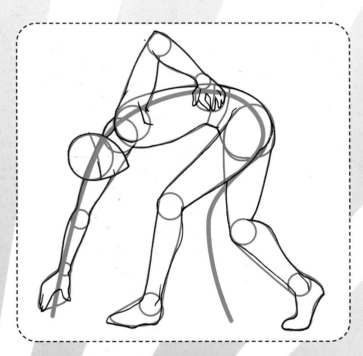

◀ In the man's case, the action line helps to place his right arm in a natural, curved position. It is also helping to position his legs an equal width apart to maintain the overall sense of balance. Once you have drawn the action line simply mark in the correct ratios for proportion along it – then add shapes, if needed, to build up the bulk.

▶ For the female, the action line ensures that the playful kick she is giving is realistically joined to her torso and curved lower back. Her shoulders are also hunched slightly forward to match the way she is curled.

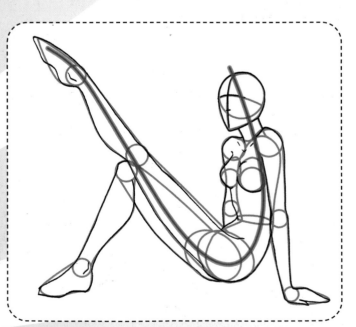

Stillness and Movement

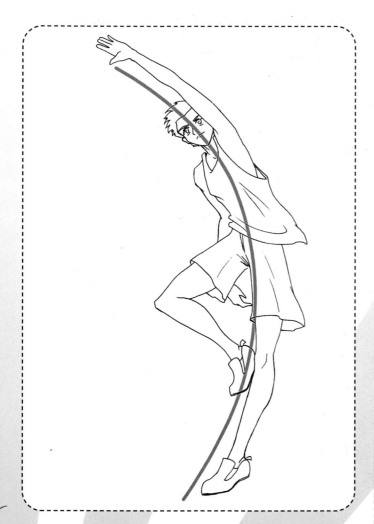

◄ This basketball player is leaping up to intercept a ball. This is a very dynamic pose, with limbs stretched to the limit. To recreate this pose, you need to draw a long, wide curve for the action line – this helps to place not only the spine and head, but the outstretched arm and the leg he's jumped off from. The burst of energy is all focused on a singular movement upwards, hence his overall pose is very closely linked to the action line.

▶ A ballet dancer has paused, finely poised on tiptoe. In this picture, the purpose of the action line is not to define movement, but to ensure she is correctly balanced. Even though she is standing upright, notice there is a very slight curve to the action line. This gives a sense of momentary stillness, but also of realism as it is rather unnatural for a body to conform to perfectly straight lines. The action line also allows you to assess her balancing limbs on either side. As her left limbs are bent inwards, they equally counterbalance her outstretched right arm.

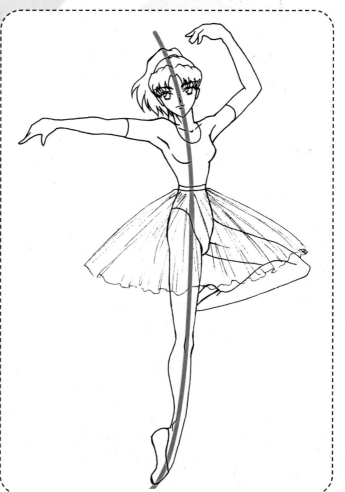

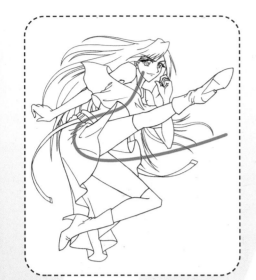

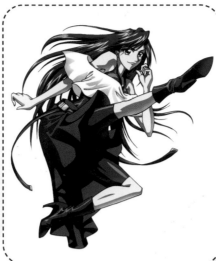

◀ A confident lady gives a flying kick! This pose requires you to think about the action line in three dimensions as her kicking leg is in front of the rest of her, dangerously close to us. The action line therefore starts quite far away, then as it follows her spine, it gets closer and closer. See how the action line still helps to balance out the limbs on either side of it.

▶ This girl is struggling with the heavy weight of her books while walking. This means that she leans back to help counterbalance the books she is holding in front of her. See how the action line is like the second stroke of the letter "K", curving back on itself?

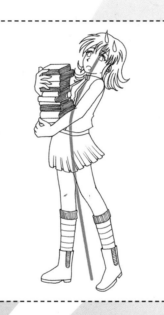

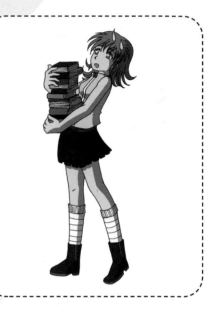

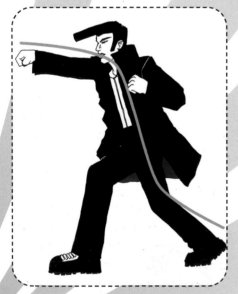

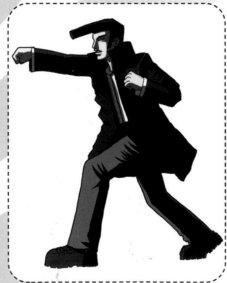

◀ The high-school bully with a razor-sharp haircut has just thrown a punch at a hapless victim. To throw a hefty punch, he has to step forward, usually with the opposing foot so that there is a suitable amount of twist in the hips to add to the momentum of the punch. The action line is like a stretched "Z" to show this movement. However, as he has just thrown his punch, he has paused. Check that he can still stay upright in his position.

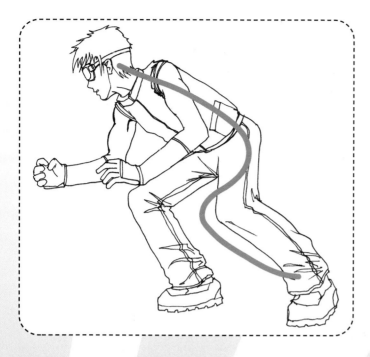

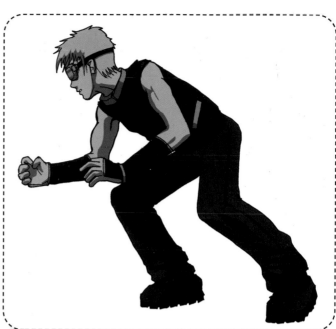

▲ This cyber-surfer is nearly in a crouch position, compact and poised for readiness to react to any form of attack. So his action line is, appropriately, like a coiled spring.

▲ His feet placement indicates he is finely balanced, his bent knees have a lot of stored energy behind them, ready to spring straight into a leap. Add to the feeling of tension by drawing angular fingers and bent arms with some raised muscle.

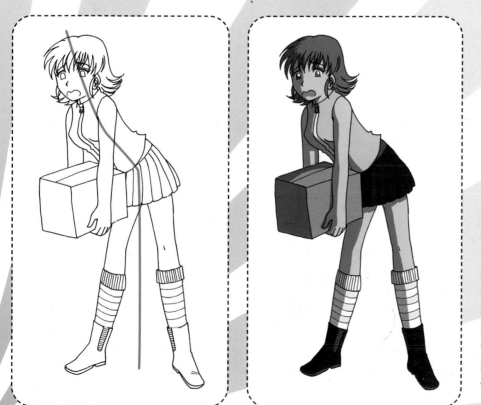

◄ This poor girl still has to clear up a few more things – now she's lifting a heavy box. She's a little inexperienced in the correct method of lifting heavy objects, so she has simply leant forward with straight legs and taken it off the floor. You can see how it's placing a strain on her by following her action line, which is now bending the opposite way to what it was in the previous example.

Tutorial: Interaction

We have already looked at how the manga body is constructed, so let's take a look at how two or more figures can interact with each other. The beauty of expressive artwork is that there is not always a need to draw entire figures – sometimes just small fragments of an image are all that is needed to show the interaction. As always there are basic rules that should be considered.

Location ▼

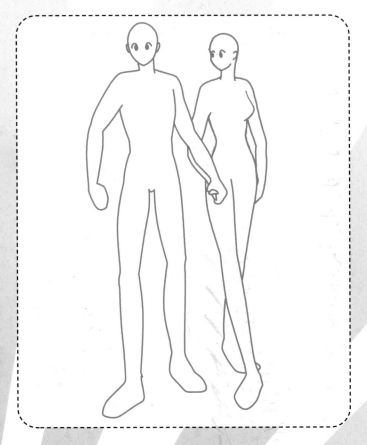

Be aware of your characters' position in relation to each other and to their surroundings. If two characters are close, then they are likely to be standing on the same ground level. You can portray this by placing their feet appropriately.

Proportion ▼

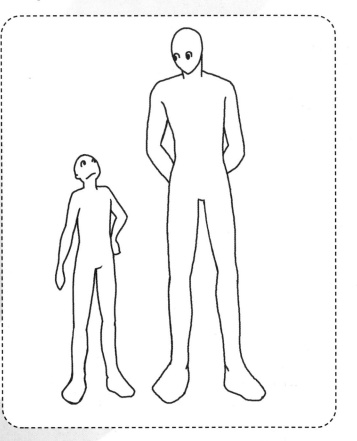

Your characters must be in proportion with each other. This can be a tricky skill to master – try blocking out your characters before drawing in detail to make sure they "match". Although some relationships will demand that one character is bigger than another (an adult and a child for instance), make sure that your proportions are always realistic (see Figures and Proportion, pages 18–19).

Placement ▼

If one character in an image is in front of the other, be sure to be coherent in your details. Here we can see an image showing how confusing lack of attention to detail can be. Which character is standing in the foreground?

Anatomy ▼

Sometimes when drawing two figures together, it can be very tempting to lengthen a limb in order to make a pose work. Here, we see that the male's arm has been lengthened abnormally in order to fit around the female's shoulders. In this situation the correct thing to do would be to simply move the female closer in so that the male's arm would reach.

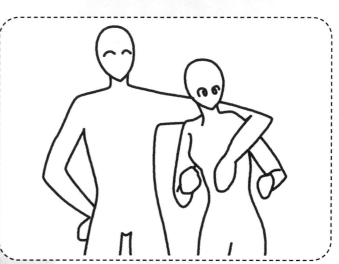

As with any element of manga, some rules can be stretched in order to provoke a reaction. If a character is supposed to be particularly scared or timid then they may appear smaller than usual; if they are confident and bold then they may appear larger. Often male characters with wandering hands may be drawn with arms that are wildly out of proportion to suggest their reach. In general however, it is always useful for the artist to know the basic rules before they attempt to tamper with them. Photographs and observing in real life are a great way to see how people interact. And remember, there are ways around drawing entire figures. Often a small fragment of an image is enough.

Examples ▼

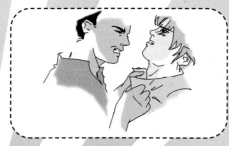

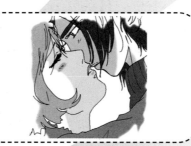

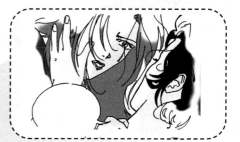

One character is angry with the other. Although we cannot see the entire arm, there is no doubt in our minds that the older character is grasping the other's collar angrily. The point of interaction has been shown and the viewer can piece the rest of the image together.

Though full height romantic shots can have a great impact, focusing on one point of interaction (the lips) can show more detail and expression. It also lends an intimate feel to the scene. A close-up pulls the reader/viewer into the action as opposed to a wide shot where we feel detached.

This shot shows one character lying down and the other looking shocked or upset. This unusual choice of angle means that the expression on the worried character can be clearly seen. The close-up emphasizes the importance of the moment.

Tutorial: Clothing

Clothing your characters can be the most enjoyable part of creating manga. Costumes can range from cool, laid back street style to futuristic, space opera suits – this is an area where you can let your imagination run riot. Clothing plays several important roles:
• It communicates to the reader the setting of your manga
• It reinforces your character's personality
• It is practical for the character's actions

Clothing can be the most effective tool in portraying the setting of your manga. With just one look, readers can understand the location, time period and genre of your story. If your character is wearing a full suit of armour, he is most probably a fantasy character of medieval lore.

What a character wears reveals much about their personality. For example, only a confident woman would wear a revealing bikini. When a character doesn't have so much choice over clothing or has to wear a uniform, it's not so much what they wear, but how they wear it that gives away their attitude. Rolled up sleeves, a messily-tied tie, loose socks, a tightly tucked-in shirt – all of these are tell-tale signs.

Think about what your characters will be doing in your manga – they need clothing that is suitable for the story. So, if your character is a desert princess, she needs a thin, light, yet regal gown.

Using the Body as the Base

It is important to draw or bear in mind the human form before adding clothing. Clothing lies over the body, but should not be used as an excuse to hide incorrect anatomy. If drawn without proper base work, clothes can distort the figure.

It is good practice to roughly sketch out the whole body in nude, particularly if the character is wearing very tight or revealing clothing. At the very least you should sketch the bulk of the body and limbs to match the clothing. For example, there is no need to sketch out full muscle definition if a man is wearing a thick sweater, or to draw the inside leg if a woman is wearing a long, bulky skirt.

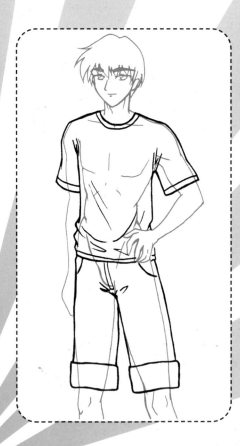

◄ Here is an adult male character in casual clothing, wearing a T-shirt and shorts. Note how by drawing out the nude body underneath the clothing it helps you figure out where best to place key features – creases and folds, the appropriate way the cloth hangs off limbs, where to place the waistband.

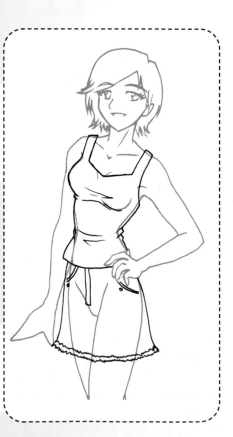

► This woman is in very tight, summer wear. It is vital to apply correct anatomy when drawing close-fitting clothing, particularly for her chest and waist areas.

Emphasizing the Human Form

▶ Now the man is wearing much more formal clothing, possibly for an office job. Here is where design features and differences between the sexes must be carefully observed – buttons are sewn on the right side, the cut of the shirt is wide for the shoulders, the position of the belt is quite low on the waist.

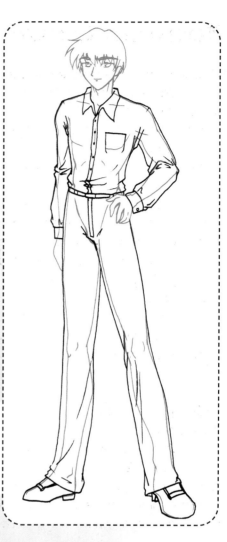

◀ The woman is also dressed more smartly now, with stylish boots and a collared, tailored dress. See how feminine the dress looks. Her figure is emphasized in this design – her dress is tied at the small of her back, creating some folds and gathers at her bust and waistline.

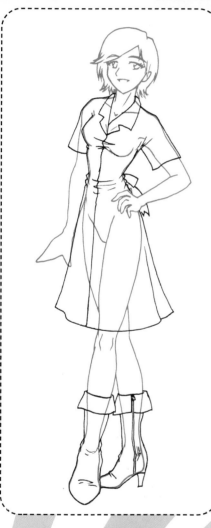

Enhancing Realism and Finishing Touches ▶

In manga, shading and colouring can add that final touch of realism that lineart hints at. (Further examples are shown on pages 34–35.) Folds, gathers and creases should be depicted using minimal, fine lines to create the feeling that it is still the same piece of material – thick lines indicate an actual break between objects. Therefore, shading finishes the effect, enhancing folds. Use a mixture of curved shapes to bring out the roundness of the bust and sharp edges for thin creases.

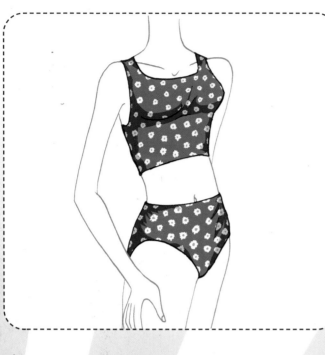

▲ A tank top bikini with a daisy pattern is a typical outfit for a teenage girl with a sweet nature to wear at the beach. Be sure to draw out the body in nude when dealing with such a tight outfit.

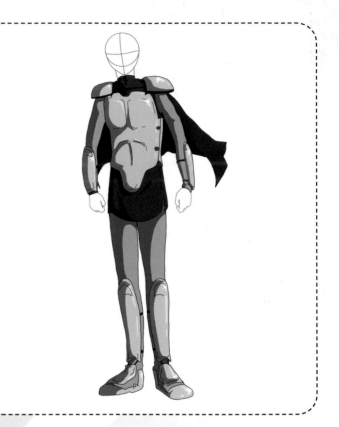

▲ A golden suit of armour fit for knights of old. Use dramatic shading on metals – don't be afraid to use very dark, contrasting shadows and pure white highlights.

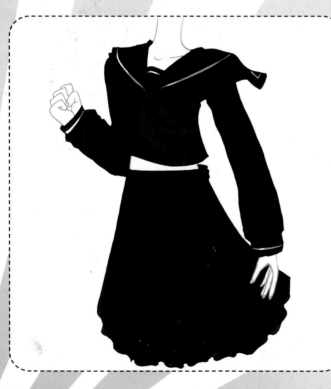

▲ This school uniform is often seen in manga and anime – this is a Japanese schoolgirl uniform for the winter season. Draw in the details of the famous "sailor" collar carefully and add a brightly coloured neck tie.

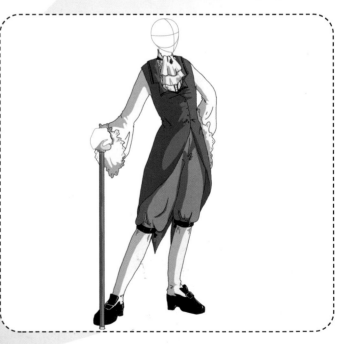

▲ A distinguished gentleman in period dress with Baroque- and Regency-influenced embellishments. Make an effort to draw in the small details of his cravat and brooch.

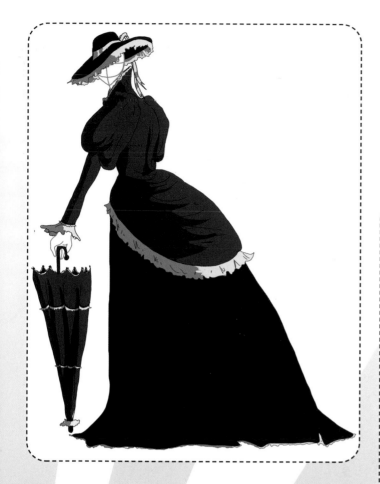

◀ Another outfit based on historical costume, this would suit a domuro young woman of the Victorian era. Draw a very pinched-in waist, as she would be wearing a corset. The lace detail ties her whole outfit together, visible on her dress, hat and umbrella.

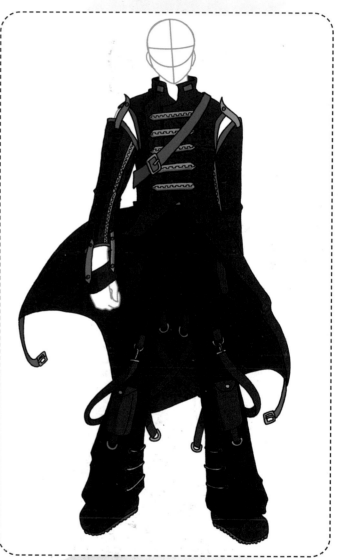

▶ A modern day ensemble, which could be worn by a teenager or young man to go out clubbing with friends. Contrasting neons, chunky zips and many straps and buckles are quite popular in the cyber-goth fashion. The overall design is simple – concentrate more on embellishing the outfit.

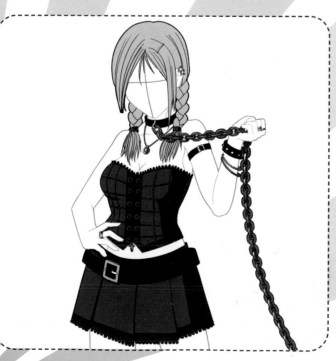

◀ This is a punk princess! A mixture of cute and sexy, her top and skirt are well complemented by her accessories. Observe the way the tartan pattern is drawn on her top – the stripes mould to her contours, helping to define her body shape. Be consistent with the frill and lace-up details, make sure they are evenly spaced.

Tutorial: Accessories

Accessories are a very important, but often overlooked part of costume and character design. A character's accessories should represent their personality, occupation or hobby, and even the kind of world they live in. While accessorizing your characters is essential, it's important that the accessories are appropriate.

The following are examples of accessories you might want to use on your characters. Try to coordinate your character's accessories. Look at the examples shown at the top of page 37 – there is a theme running through their various adornments.

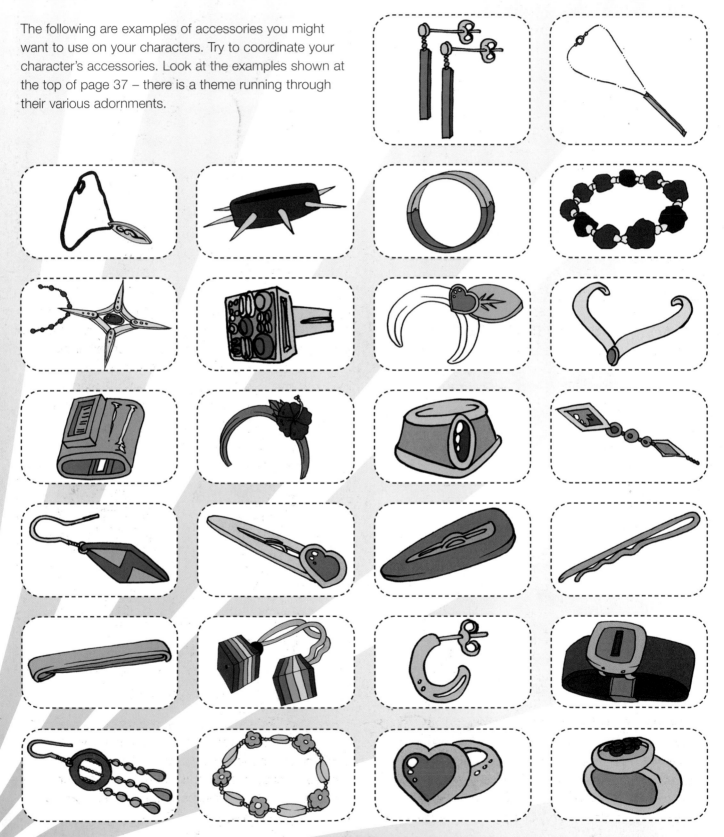

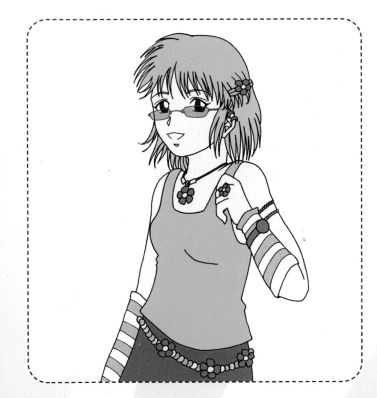

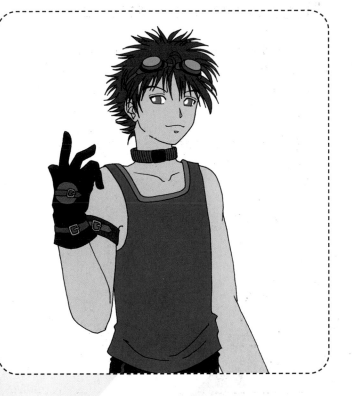

▼ Adding Accessories to Show Character's Circumstance

Even a generic character can be transformed by a clever choice of accessories. Look at the examples below. See how she changes from a dull schoolgirl, to a confident fashionable character, to a sci-fi adventurer, to a fantasy heroine.

Even though the fantasy and sci-fi characters here are quite an unusual combination of contemporary dress and fantasy accessories, they work within context. If the character is in a whole school of sci-fi or fantasy students, then the uniform is completely acceptable. However, if they are surrounded by regular students in a regular school, their outfit would look out of place.

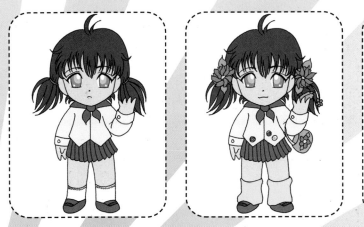

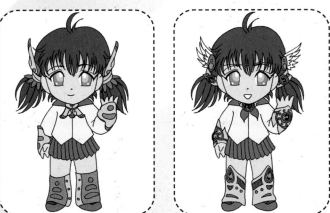

Creating Meaningful Accessories

Many accessories work best when they have a function or a reason to be there. If your character has a lot of belts strapped around their waist, why are they there? Could they hold something, for example, a weapon or tools? Does your character have a job that requires any specific accessories, like gloves, hats or goggles? Their accessories could even be part of a uniform, like a bandana specific to a gang or friendship bracelets shared between groups of schoolgirls. Consider these points and try to incorporate accessories which are useful to the character into your design.

Tutorial: Lighting

Lighting helps to define the three-dimensional shape of an object and makes the drawing much more believable. It can communicate the relative position of a character within a world and explain their surroundings. It can also be used as a method to express emotions and dramatic atmosphere, completely changing the way a picture is perceived by the viewer. By understanding and applying some simple lighting methods to your artwork you'll be able to vastly improve the look of any illustration you do in the future.

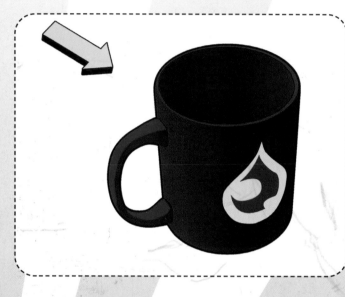

◀ Basics

The most basic and important principle of lighting is that the object is lightest on the parts which face the light source, and darkest in parts which face away from the light source (as illustrated with the yellow arrow in the diagram).

If a light source has a small area of influence, like a dim light-bulb or a candle flame, then the object will be visibly brighter in areas closer to the light, becoming darker further away. However, most light sources continue for a long distance until they hit an object.

Shadows ▶ ▼

When an object intercepts a light source, it will cast a shadow on other objects. The presence of shadows is one of the most important aspects of establishing the shape and location of an object, so it's worth spending time on drawing them. In this diagram, you can see the shape of the mug has been cast on to the white surface.

Items with detailed surfaces such as folded fabric or heavily carved armour will often cast shadows on itself and this can act as an effective way to vividly define detail.

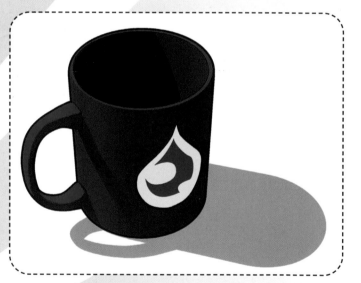

Also, semi-transparent objects, such as plastic bottles, cast coloured or translucent shadows, which can lead to some dynamic visual effects.

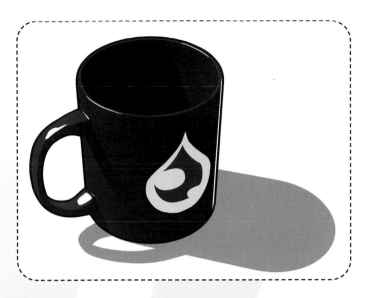

◀ ▼ Shiny and Reflective Objects

Some materials are more reflective or shiny than others so they tend to catch much more light than matt or dull objects. Dark and light objects are seen in the surface, and this leads to the item having a shiny look with heavy contrast. Strong back-lighting at the darkest part of the shadow is often employed to define volume and imply an especially shiny material.

Many artists tend to ignore realism to some extent when dealing with shiny objects, preferring to render them to a learned method. Fake glints and highlights are used to emphasize the type of material. For cylindrical objects such as poles or even legs it can be effective to draw a thin line of highlight. This technique is often used on hair to make it shine brightly.

The way shiny materials are drawn in anime style varies heavily depending upon the artist's preference. Pay attention to artwork and look for styles that suit you.

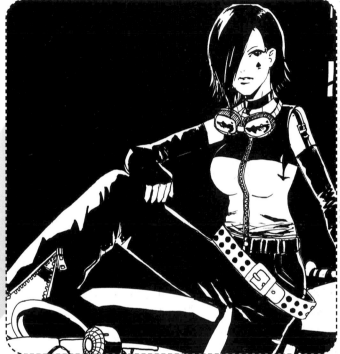

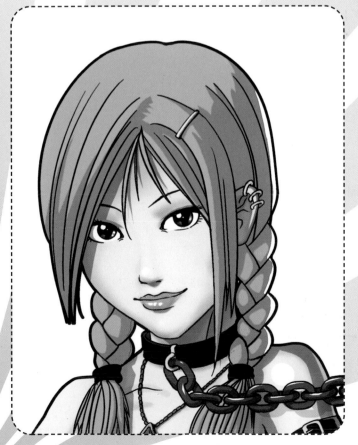

◀ Lighting Tips

- Hair – draping hair should cast shadows on the character's forehead and face. The artist has chosen to light the hair with a strong back-light.
- Nose – a subtle shadow beneath the nose helps show its shape.
- Lips – the lips have been given extra highlights to show their shine. The bottom lip casts a small shadow also, giving the lips a sense of shape.
- Eyes – the glossy eyes are reflective of many different colours, in this case blue and pink shades have been chosen to complement the colours used, finished off with bold white reflections. The eye sockets are defined with a subtle suggestion of shadow, setting the eyes back slightly from the brow.
- Neck and shoulders – shadows are cast from the chin on to the neck, and the plaits of the hair cast a shadow on to the body. Be sure to include all objects and overlaps when drawing shadows on a character.

Tutorial: Colour Theory

Choosing the right colours for an image can often be just as significant as the illustration itself and can sometimes be just as difficult. Not only can the mood of an image be changed by the use of colour, but the focus and general effectiveness of the composition hangs entirely upon the colours chosen.

Basics of Colour

So, how do you go about choosing the right colour? Should you choose the colour which is technically correct, or because you personally prefer it? Whatever your motive, it's important to understand the generally accepted associative values of colour and how it can be most effectively complemented and emphasized. Colour theory will allow you to be more confident with your colour choices and make the most of the look you want to capture.

The colour wheel organizes and explains the basics of colour. It is also a valuable tool to help you choose your colours and to judge the relationship between different hues.

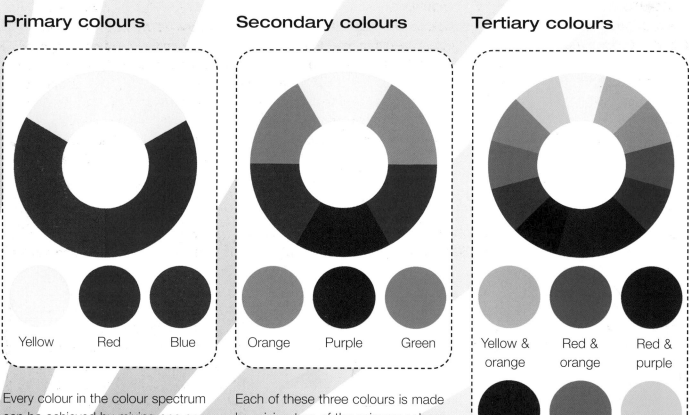

Primary colours

Yellow Red Blue

Every colour in the colour spectrum can be achieved by mixing one or more of these colours together in varying quantities.

Secondary colours

Orange Purple Green

Each of these three colours is made by mixing two of the primary colours together.

Tertiary colours

Yellow & orange Red & orange Red & purple

Blue & purple Blue & green Yellow & green

Tertiary colours are mixed from one primary and one secondary colour.

Colour Palettes

Using the colour wheel, it's possible to make informed decisions about which colours you use for your manga characters.

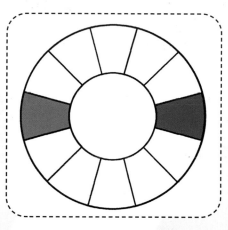

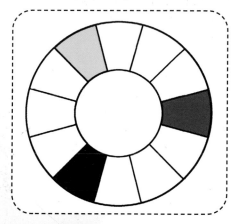

▲ Analogous/related colours

Analogous colours are close together on the colour wheel, but far enough away to introduce variety to the hue of the image and keep things interesting. Three or four neighbouring shades may be chosen to achieve this effect.

▲ Complementary colours

Colours from opposite sides of the colour spectrum have the greatest contrast with one another, but the effect can often be garish. When one of the colours is duller, then the complementary shade can function as a striking accent colour.

▲ Triadic colours

A triadic palette comes from choosing three colours from the spectrum which are evenly spaced from one another. Typically, two of these colours are used as the basis of a colour scheme, with the third being used occasionally for high-lights and accents, as it is equally contrasted to each of the other two tones.

Significance of Colour

Different ranges of colours tend to evoke different emotional responses, so it's important to pay attention to the way colours can be interpreted. The use of colour applies not only to the palette you choose, but also the tints and shades of any lighting in the scene.

Warm colours

Red, orange and yellow – these colours give the impression of warmth because of their association with fire and sunlight. While yellow is the most visually bright colour in the spectrum, it is red that is the most striking and alarming.

Cool colours

Blue, green and purple – these colours suggest a cool sensation because they remind us of water and grass. They typically attract less attention than warm colours and are more relaxing, even in their richer variants.

Neutral colours

Grey, beige and dull-brown – grey is the most neutral of all colours. Therefore it does not contrast with other colours and removes focus from objects in this colour. The use of neutral colours can be especially effective with bright or rich colours.

Colour coordination

Simply coordinating the colours within a character's outfit and accessories is often enough to create a strong visual look. Whether you choose similar neighbouring colours or outlandish and bright hues, it's important to retain a persistent palette. Try to choose tones of similar saturation or intensity, and be sure to echo colours throughout the design. For instance, if a character has rainbow-coloured arm-warmers then consider giving them rainbow-stripe shoes to match.

Tutorial: Chibis / Super-deformed Characters

Chibis are cute, pint-sized characters with small bodies, huge heads and even huger personalities! Mostly these types of characters are used for comedic or light-hearted drawings or comics, or as cute mascots. While they may look simple to draw, it's much easier to create chibis if you already have a good understanding of how a standard manga character is pieced together.

Anatomy of a Chibi ▼ ▶

In contrast to regular sized manga characters, Chibi anatomy is very deformed and simplified. Chibis are a mere two and a half heads tall, with rounded faces and enormous eyes. Their bodies are very simply drawn, with little or no muscle tone or definition.

The two images below and opposite right highlight points of the style to pay particular attention to:

- Shape of skull is very distorted. The facial features are very low compared to full size characters' faces.
- Cheeks are small and low down. The chin is a very shallow "V" shape.
- Chibis very rarely have necks. Generally you will only see a small part of it at the back of the head.
- Chibi hands have tiny, pointed fingers.

- Legs usually take up at least 50 per cent of the body. Shorter legs would make the chibi look even more squashed!
- Hair is one of the few parts of chibis which is drawn with as much detail as a regular sized character.
- The eyes take up about as much height on the face as the nose and mouth.
- Chibi shoulders are nothing more than a gentle slope from the neck. Narrow shoulders help make the character look more childlike.
- Female chibis have very small breasts and the waist or hips are not defined.
- Accessories and jewellery are clunky and oversized.
- Chibi feet are small; barely much bigger than the size of their ankles.

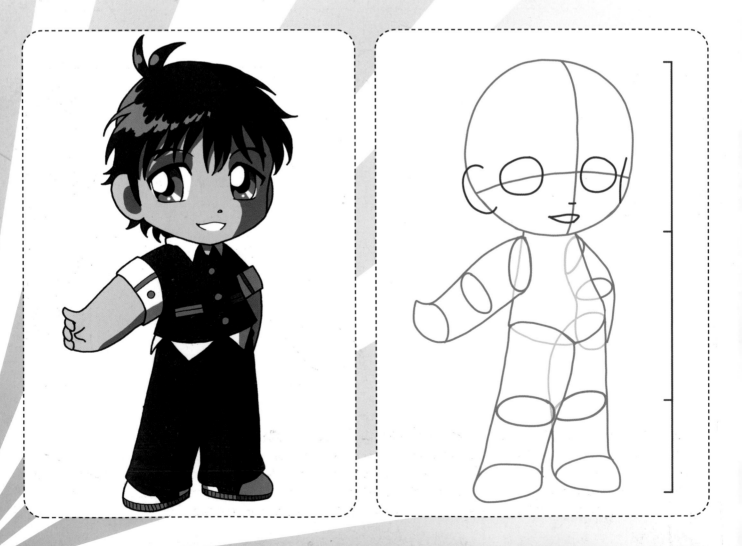

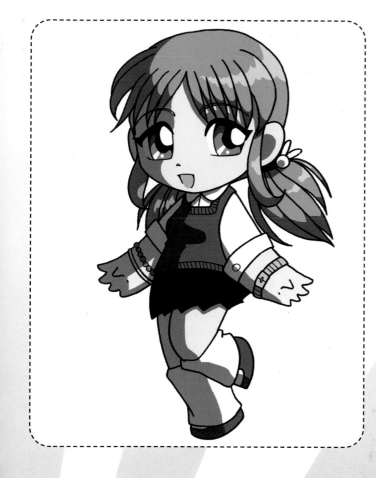

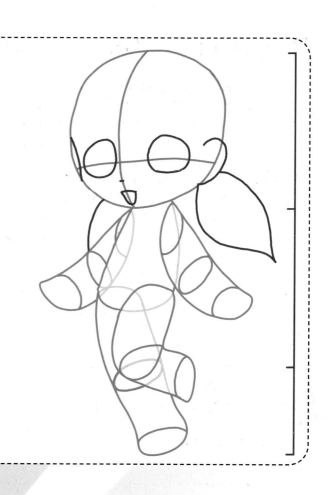

Chibi Limbs ▶

Energetic and exaggerated, chibis are great for drawing in bouncy bendy poses. The arms and legs of chibi characters should reflect this by being as curvy as possible. Also, because chibis are so compressed, a softer joint stops their limbs from looking too elongated for their bodies. Here are some examples of chibi arms and legs to show you how they bend and move.

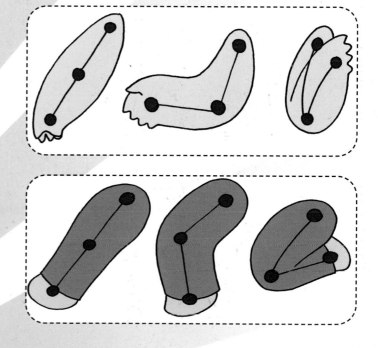

Creating a Chibi of a Pre-existing Character

Drawing a chibi version of a full size character you've already created can be easier than starting a chibi from scratch. Also, it can draw attention to the particular features which make that character design so distinctive. The focus should be mostly on the facial features and expressions, and recreating the character's clothing and accessories in chibi versions. Try to put as much of your character's personality into the drawing as you possibly can.

Step-by-Step Creation: Male Child

It is important to remember that while the design should reflect a character of roughly 12 years of age, the standard manga child tends to be far more mature than they would be in reality. Often in stories aimed at the pre-teen market these characters are given central roles, with a great weight on their shoulders and skills far beyond their age. Their true age makes them accessible to a younger audience, while their maturity opens them up to older readers.

Rough Sketch ◀

As the image shows, this design was originally marked out in blue pencil before inking. This means that when adding the inks it should be very hard to miss any lines and the sketch work can be easily removed at a later stage.

Figure ▼

The standard young boy has not yet matured. He measures in at around five heads high and his frame is small, without any of the tone or features developed in the teen years. Often, younger characters can be drawn with slightly oversized hands and feet to emphasize the smallness of their frame. This same effect can be achieved with the ears. As the character is young, the eyes are large and are set slightly below the centre of the head.

The personality and demeanour of the character will drastically effect how they're drawn. Here, the standard young boy is confident and so his head is held high, shoulders squared and loose. However, he is still of an age to be slightly wary of the world around him. He has a fixed expression that suggests he is happy, but he's being a little cagey about it. His hair is untidy; not something he's too worried about at his age.

▶ *His pose here suggests he is moving forward. Be sure that at least one foot is planted firmly on the ground to give the character balance.*

He is obviously still attending school and so in this image the character sports a school uniform and regulation rucksack. As with the body features, clothing can be drawn as slightly oversized to emphasize the smallness of the frame. The outfit shown is loose and comfortable. There are minimal creases in the top, but they are enough to show how much movement there is in the material. For young male characters especially, the style of long shorts used can really show their age. These boys are too old for shorts, but not yet old enough to feel comfortable in full trousers. This character's true personality is shown in his accessories.

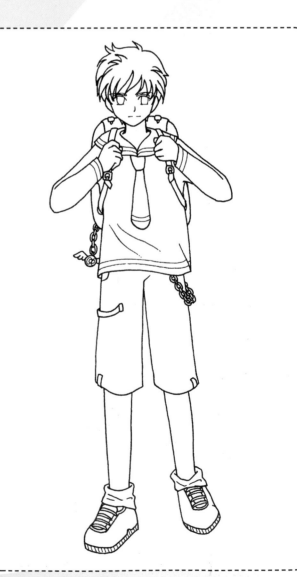

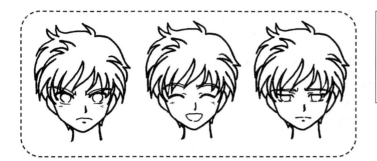

Here are some alternative looks the standard young boy might sport.

Basic Colours ▶

As far as clothing goes, in this design, he is wearing a Japanese sailor-style school uniform. Regulation colours dictate blue and white as the chief colour scheme. However, you can complement or contradict this scheme with other details. The character sports a large red rucksack. On a design level this adds a splash of colour, on a character level this suggests that there is an element of the rebel in him!

His skin tone is slightly tanned. This is a character that probably spends a lot of time outdoors and so pale, white skin wouldn't suit him.

As the character is a realistic one, his hair couldn't really be a very unusual colour without changing the design radically, so a fairly natural hair colour has been chosen. His eyes, though again a fairly normal colour, have been coloured in a way that increases their wideness. There is no pupil, only a darker shadow of the same green. This lends the character an almost cat-like appearance and suggests that he is the inquisitive sort.

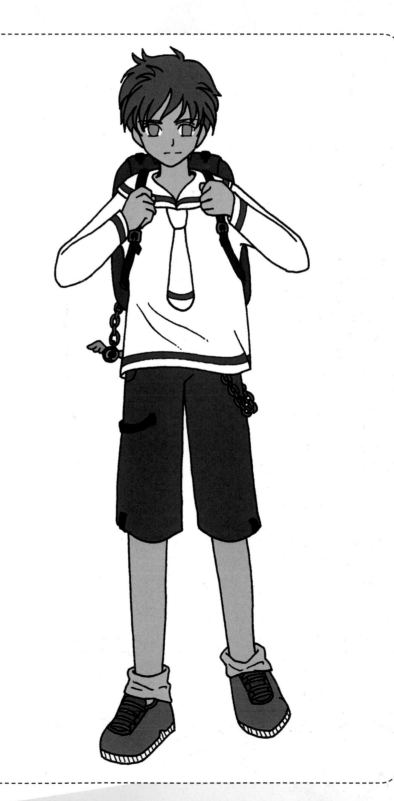

Shade and Highlights ▼ ▶

The style of shading used in this image is simple to match the clean lines of the design. One layer of shade has been used throughout, rather than building up any kind of gradient. As with any picture, care must be taken to ensure that the shade is coherent. In this image you can see that the light source would be somewhere to the left and above the figure as all of the shade falls to the right and below.

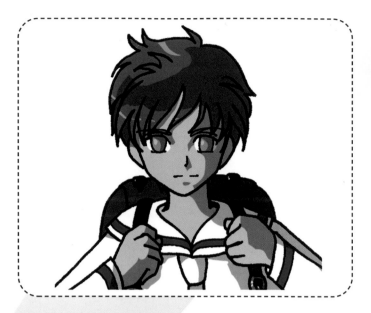

Highlights are kept simple and are only used on key areas: the hair, eyes and metallic buckles. In each case, rather than a pure white highlight, a lighter shade of the same colour has been used.

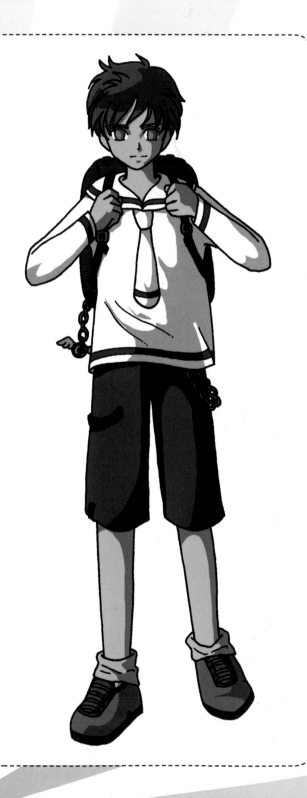

The boy has attached a chain to his shorts and also wears an unusual key-chain on his bag. These items show a desire in him to be a little bit different and not to conform. The key-chain is a cute mascot figure, which suggests he has a playful nature. Small features like these can make all the difference in a character design. Even when you are limited by the confines of a set uniform, there is nothing to stop you adding details that can illustrate a character's true personality.

Finished Image

Personality
Confident, inquisitive, rebellious, playful
Setting
School, modern day

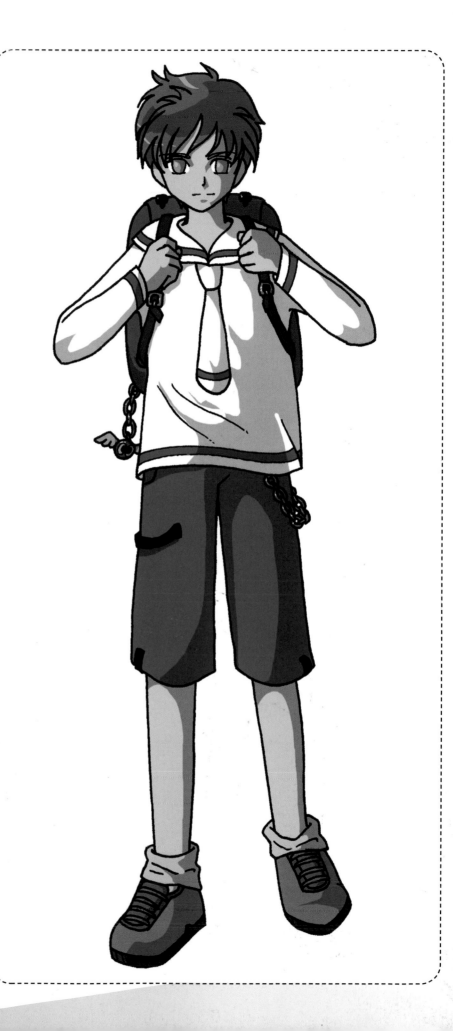

Male Child
Alternative 1

This boy is from a different, harsher world – his torn clothing, yet technological accessories hint at an apocalyptic future.

Someone used to hardship and fending for himself, he is defensive and stubborn. He reacts heatedly to criticism, shaking his right fist, yet he still shows signs of naivety, his left hand is at a petulant angle as if throwing a childish tantrum. He's set his feet apart and they are firmly planted – this is a strong and resilient pose. When drawing him, it is important to use a vertical action line to ensure he is correctly balanced.

To further distance him from our world, he has unusual colouring – violet eyes and purple hair. His dark skin and flashing eyes, almost red, complement his hot temper. His ripped, white shirt and the aqua-toned waistcoat offsets and enhances the reds and dark skintones.

His outfit contains a blend of high-tech gadgets and torn, pauper-like clothing. While this may not make sense at first, it completely fits the setting of a science fiction story – a futuristic world in the aftermath of a global disaster leading to sparse resources, a race struggling to survive in a hostile environment.

Chunky, fingerless gloves suggest a tough character – lots of wires, buttons and metal plating have been added to give them an electronic look. Metal is a recurrent theme throughout the outfit, used in his pendant, on his shoes and as his belt. When trying to depict metal, use a mixture of soft blends, fades and gradients interspersed with thin, white streaky highlights. The more concentrated the transition from dark to light, the more reflective the metal is.

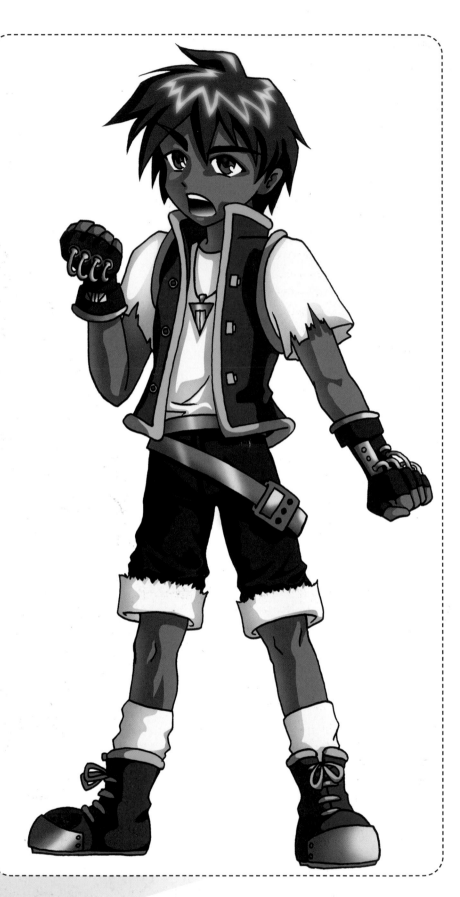

Personality
Stubborn, defensive, honest, tough, determined
Setting
Science-fiction, future, wastelands

Male Child Alternative 2

This young boy aspires to be a skilled magician one day. He is a student training in the arts of magic and wizardry, practising whenever he can so that he may gain valuable experience. He is holding a grimoire of spells in one hand while casting a spell with the other.

His stance and mellow facial expression suggest that he is confident in his abilities. He's enjoying the craft of magic and wants to improve. With a calm, relaxed smile and overall peaceful expression, it's obvious this boy is someone who dislikes violence and conflicts.

The light colours, such as his shiny blonde hair and bright blue eyes, reflect the boy's laidback attitude and gentle personality. However, it hints that he can also be naïve and overconfident at times.

You can tell he is from another world from the design of his clothes and the presence of magic fire. A long cloak and fancy-looking shawl decorated with a silver trim and held together by clips with golden buckles give the character the appearance that he is from a role-playing game fantasy world.

The colours of his outfit also help to identify that he is a fantasy-type character. Brown leather is commonly used in fantasy designs, therefore the use of brown for the book, his belt and the clips on his shawl and shoes make his setting more recognizable, as well as adding a common accent throughout the image.

This is complemented with the main colour combination of indigo and white for the whole outfit, which is dark in comparison to the boy's hair, eyes and magic fire. The purple and greys used in the outfit give him an air of mystery, without making him look aloof. Use long streaks of highlights and shading to bring out the folds in his cloak.

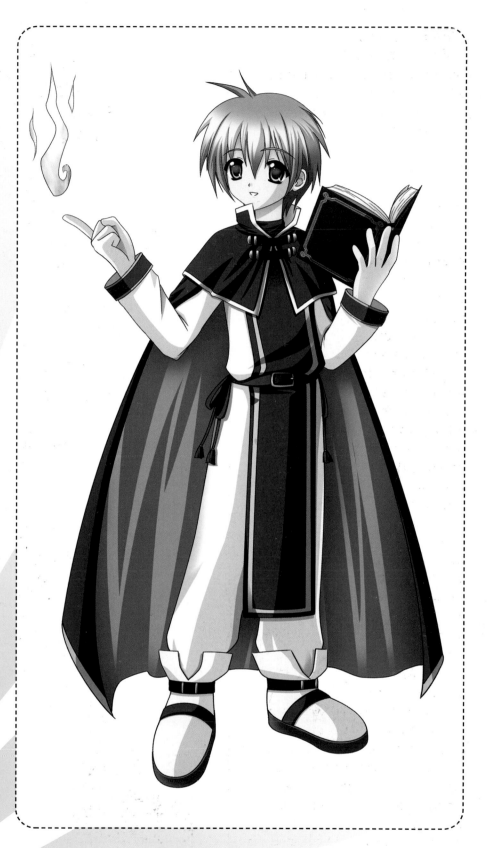

Personality

Optimistic, confident, thoughtful, trustworthy, hard-working, naïve

Setting

Fantasy, magic, school, academy, laboratory, castle, adventure

Step-by-Step Creation: Female Child

At first, very young characters may seem to have very limited roles in manga; maybe they're an annoying younger brother or sister to the cooler teenage protagonist, or just in the plot to be rescued by an older, stronger character time and time again. However, there is a whole wealth of stories out there aimed at young children with protagonists they can relate to. Often, in comics aimed at young girls, the protagonist has some sort of magical power or special talent that sets them apart from their peers. These kinds of stories reflect the fantasy and innocence of childhood, and are hugely popular with children in both Japan and the West.

Rough Sketch ▼

The figure is built up lightly in pencil. The lines are quite loose and will be tightened at the inking stage. If you are confident, you can sketch quite quickly and freely and leave the neatening up and details until the inking stage.

Figure ▼

Young characters, similar to this girl, have almost exaggerated looking proportions. This character is a mere four and a half head heights tall, and has a large head with huge eyes and a small nose and mouth, which make her look younger and more innocent.

She also has narrow shoulders, which add to her young appearance. As young children have barely developed, their anatomy is very immature. The character here is around six years old, so she still has small, dainty hands and feet. Her fingers are small and round, but without looking too fat. Also, she has no definition around the waist and hips.

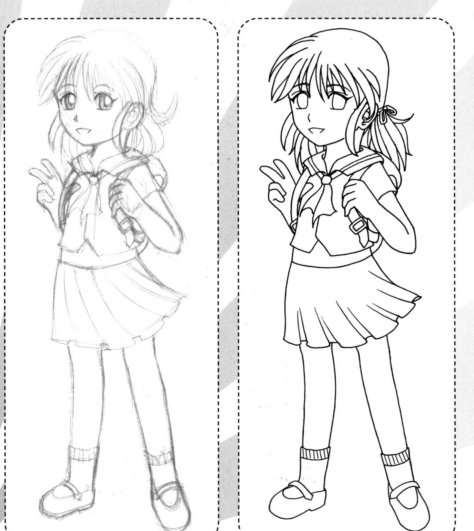

This character is wearing a school uniform, a modified version of the traditional "sailor fuku" (sailor suit). The collar on her shirt is more square than it would be typically, and the pleats on her skirt are less rigid and flow more freely. Her shoes are "Mary Janes", which are quite typical of the simple shoes children wear.

Even though she is wearing a uniform, her personality can be shown through small details in the design. Her ribbon-tied bunches show she is quite girly, and her neat short socks show she is quite prim (as opposed to a more tomboyish character, who would have messier hair and socks that were falling down). She appears very tidy and is probably a good student.

Take particular care when inking details like her hair ribbons, the stripes on her collar and the buckles on her bag straps – don't be afraid to switch to a finer-tipped pen to make things easier.

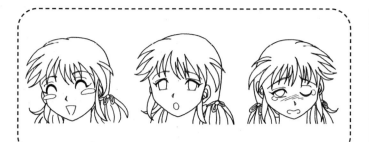

◀ *Here are some expressions you might use on characters of this type. Children are often very happy and bouncy, or curious and confused, so those types of expressions suit them best. More adult expressions, like sarcastic ones, could look inappropriate on a young character.*

Points of Design ▶

Very young children have not yet developed much of an interest in fashion. As such, it would be inappropriate to give them too many trendy accessories, or too daring an outfit. But that's not to say they should be completely unfashionable. Try to make young characters' clothes look contemporary, but not too over the top. Cute, stylish logos and other simple designs work well in place of fashionable accessories – for example, a school bag with a cute animal mascot logo.

Basic Colours ▶

The character's uniform is an unusual colour (the standard palette for sailor suits is blue and white). When relying on traditional design elements, don't hesitate to make them more unique by experimenting with colour schemes. Even though she is a child and should be quite active, her skin is a pale tone, showing that perhaps she spends too much time studying indoors instead of playing outside. Her hair is shaded in a cute, girly shade of pink.

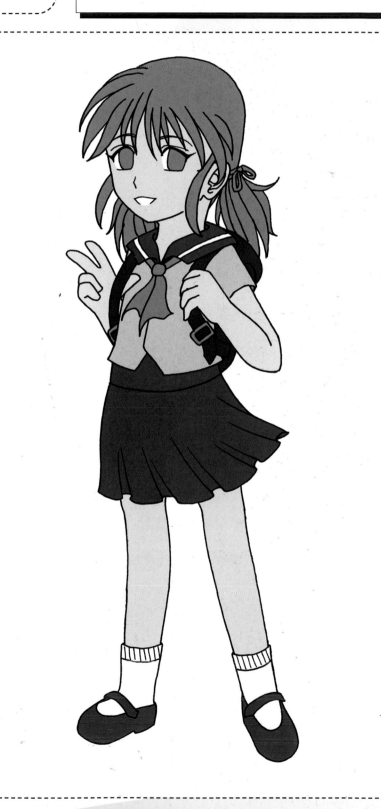

Shadows and Highlights

The shadows are added in warm shades to complement the pink colours used in the image. Remember to add shadows in between the pleats of her skirt. To bring out the shine and texture of her hair, light pink highlights are added in jagged streaks. Her eyes also have bright white highlights in circles and ovals to emphasize their roundness.

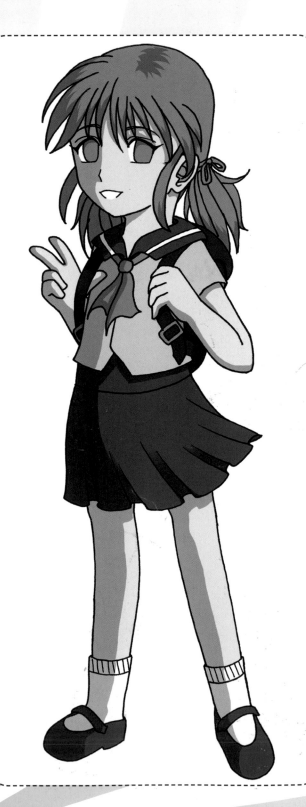

Finished Image

Personality
Cheerful, shy, gentle, kind, neat

Setting
Contemporary, school, after-school clubs, home

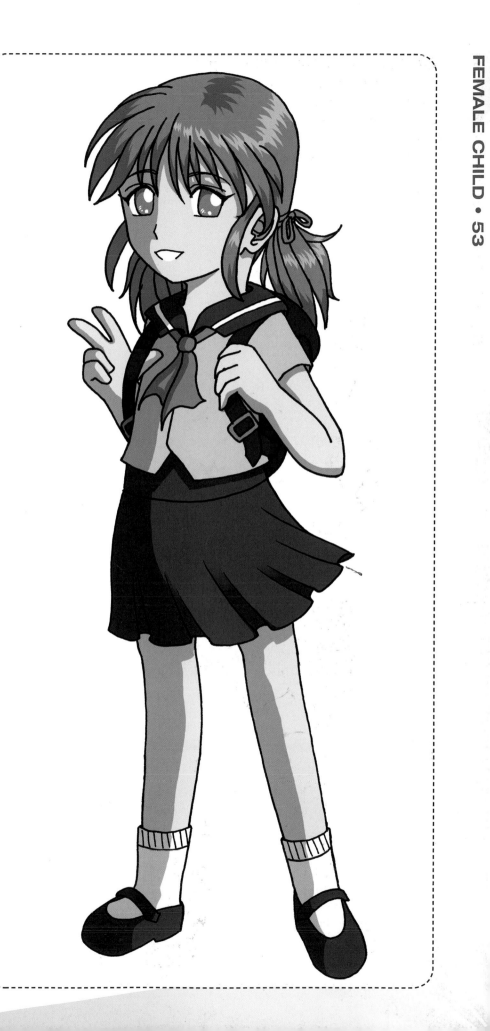

Female Child Alternative 1

This character is very commonly seen in anime and manga – the magical girl! She's a bright, happy, outgoing little girl who magically transforms into a fairy princess to save the day, with a magic wand and a cute little animal sidekick.

She is drawn in a fairly realistic proportion set of four–five head lengths, but she has very large, expressive eyes with very little white showing – this makes her look cute and trustworthy. Her stance is confident, leaning forward with feet firmly placed. She holds her wand in a cute, girlish way, arms fully extended and both hands close together. Her exaggerated hair is very long, wavy and softly luminous in a magical blue. It's tied into a ponytail with a ribbon, in line with her active nature. The ringlets framing her face also add to her prettiness.

The velvety blue of her hair inspired the rest of the colour scheme in the picture – cool, pastel and smoky shades of blue, purple and green. Her dress is very pretty, with puffy sleeves, ruffles and many skirt layers. Don't be tempted to let the costume hide incorrect anatomy – draw the body outline first before experimenting with an elaborate costume.

Note the colouring on her wings and on her mascot – the shading and patterns were actually inspired by the natural world. Her wings are coloured like a seagull's, white with a short fade into black tips. Her mascot has bat wings as a design contrast, but is coloured entirely in shades of green. It still looks very realistic, due to soft, natural shading – the stripes are based on a normal tabby cat.

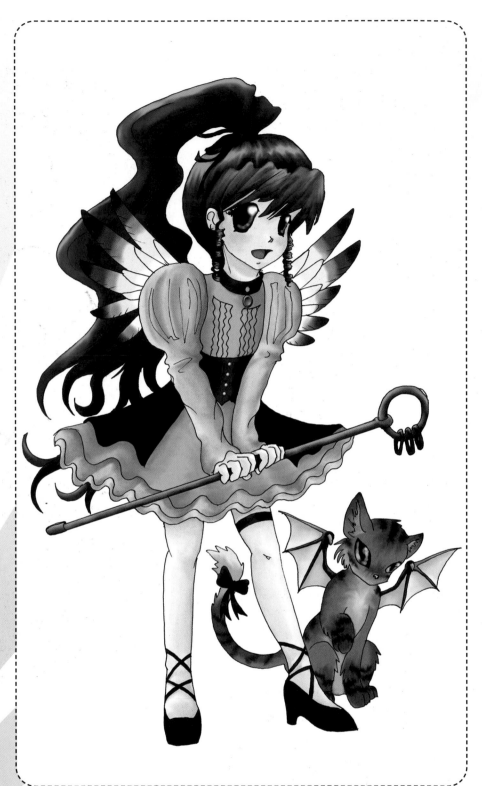

Personality
Bright, cheerful, energetic, good
Setting
Modern, fantasy, romance, action

Female Child Alternative 2

This little zombie girl has elements about her that mix up popular culture themes from both east and west; gothic Lolita elements of Japanese street fashion, mixed with Frankenstein zombie horror themes, drawn in a cute "super-deformed" manga style.

The proportions may seem strange at first; make sure her head is no wider than her body. Her body should be chubby so, theoretically, it supports her head. Her wings must be equal and symmetrical. The pupils in her eyes are slightly pointy which would imply a vampirish nature. Her legs and arms can be quite chubby; her feet should be rounded and chunky.

She is dressed in typical little girl fashion but shows a dark side to her girlishness with her medical kit and awkwardly stitched-up plush toy (which is ironically falling apart). Stickers and plasters mark out her clumsiness, her earrings and skull fashion motifs give her an appealing contemporary edge. Her green skin tones complement her purple dress and match her setting. The cross on her lapel and lunchbox suggest she is following some kind of surreal nursing course.

Her eyes are large suggesting innocence, but their shape hints that she knows more than she should! Her hair is bobbed sensibly but has smallish strands which require attention to detail when reproducing.

Her stance is a very innocent one, emphasized more by how her feet are pointing inwards and an insecure finger near her mouth as if she is nervously chewing on it. Has she done something wrong? Is she prepared to admit it?

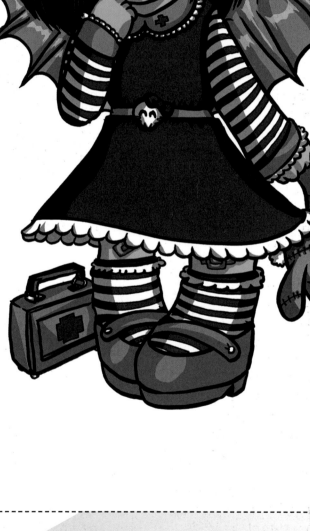

Personality

Subdued, suspicious, shy, clumsy, eager to help but things always turn out wrong

Setting

Fantasy, horror, school, gothic

Step-by-Step Creation: Teenage Male

Teenage males are possibly the most common of all manga protagonists. Offering a perfect compromise between youthful enthusiasm and freedom of youth combined with the strength and opportunity of a male character, the teenage male is in a perfect position to have conflict, battles, adventures and romance. The passage into manhood for a teenage male also represents a certain acquisition of power, both socially and physically, introducing a new circumstance and opportunity for a character to compete against other people in the world but without the experience that can make behaviour predictable or withdrawn. Most of all, the role for a teenage character is far more fun than any other age group because their actions are deemed less finite, with plenty of opportunity for reconciliation.

Rough Sketch ▶

The body has been built up gradually, firstly with faint lines and then with increasingly dark line work. Details in the clothing are included at this stage so that they can be properly interpreted when it comes to inking. Suggestion of shading and fabric folds are also sketched in. Although these details may not be fully defined until the colouring and shading is added at the very end, it allows the choice of whether or not inking detail is necessary in this area, and gives a better approximation of how the overall image will look. Certain details, such as the chains, are not defined clearly at this stage but will be rendered properly during inking.

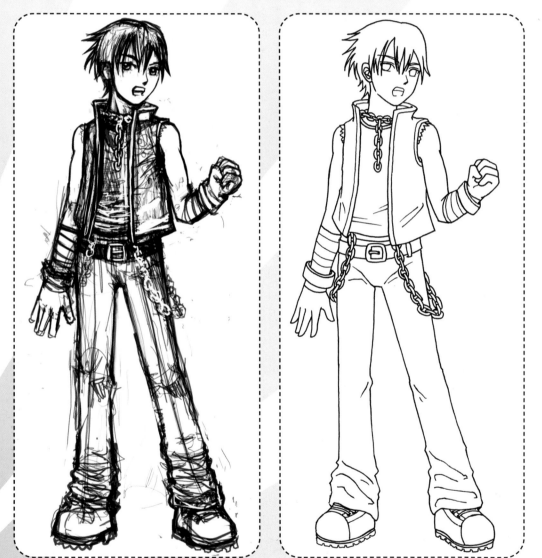

Figure ▼ ▼

Teenage males have very little definition in their body shape. Although they have matured past puberty they have not yet developed muscle tone or a full male physique. As a result the torso, hips and waist of male characters at this age are almost shapeless with only slight variation. Loose fitting clothing helps to define the volume of the limbs, with emphasis on the slight folds on the base of the vest and the way the waistcoat hangs stiffly from the sides. Detail is introduced to the centre of the image in the form of chains, wrapping around the back of the character and helping to express the volume of the figure,

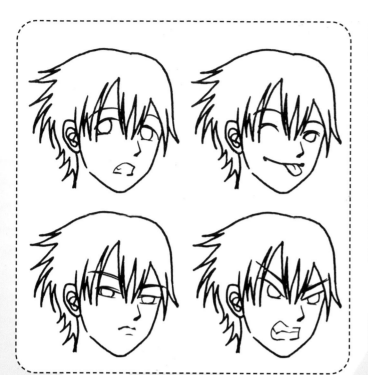

◀ *Teenagers are especially malleable when it comes to expressions, and can be more expressive than any other character type. Although teenagers often have emotions of brooding and anguish, they're also playful and joking a lot of the time, so both extremes are commonplace. Conversely, teenage characters, especially male characters, often suffer from a lack of subtlety – characters won't have developed such a defensive front or methods of hiding the way they feel at this stage, and this should come across in the way you present them.*

Points of Design ▶

Teenagers have the opportunity to express themselves quite freely with the way they dress. Fashionable or trendy choices of clothes are commonplace, with little regard for practicalities or long-term wear. This character has obviously dressed with a specific look in mind, trying to come across as a fighter or tough character, perhaps to compensate for his meagre physical stature. Chains are worn around the neck to complement those hanging off his waistband, introducing areas of detail to some of the plainer areas of the image, as well as drawing something distinctive. Arm bandages are worn entirely for cosmetic purposes, combined with heavy bracelets, tying the design elements together perfectly.

Basic Colours ▶

This character's choice of clothing is obviously well considered, so it's likely the colours would be appropriately coordinated. Opting for more autumnal shades, the choice of palette is less flamboyant and garish than some teenage characters, but possibly reflects the impression of the character being tough and not someone to mess with. The hair on this character is a deep shade of green, with details of his belt and shoes chosen to complement this. A neutral tone for the vest and bandages allow greater focal emphasis on the brown waistcoat and burgundy bracelets.

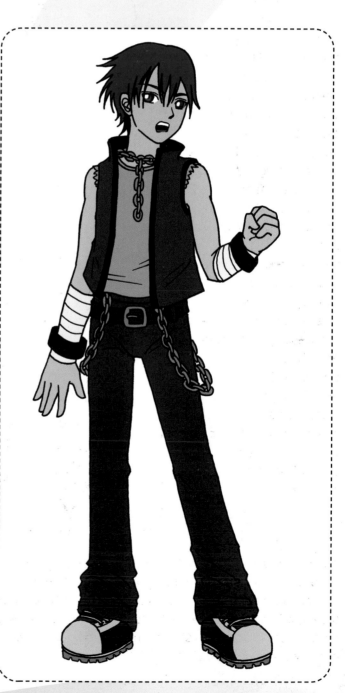

Shading and Finishing Touches

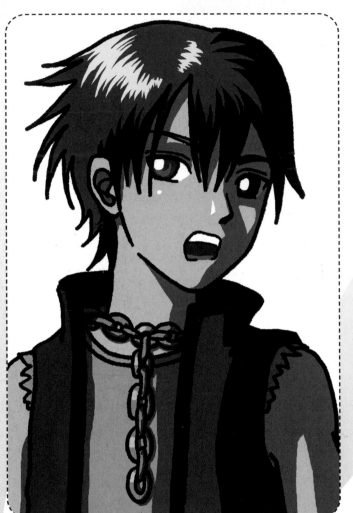

His clothing is not overly tight or loose, nor is his figure well developed, so some block shading with a few instances of folds and creases will suffice. Particular areas of importance are his head and the details of his chains. His head is tilted a fair distance away from the light, so most of the left side of his face is in shadow, but a tiny bit of light spills onto his left cheek. The chains are metallic, so require at least three levels of shading – base colours, shadows and light highlights. Each chain link needs attention, so take care!

Finished Image

Personality
Angry, aggressive, determined
Setting
Contemporary, gang or street, action, adventure, thriller

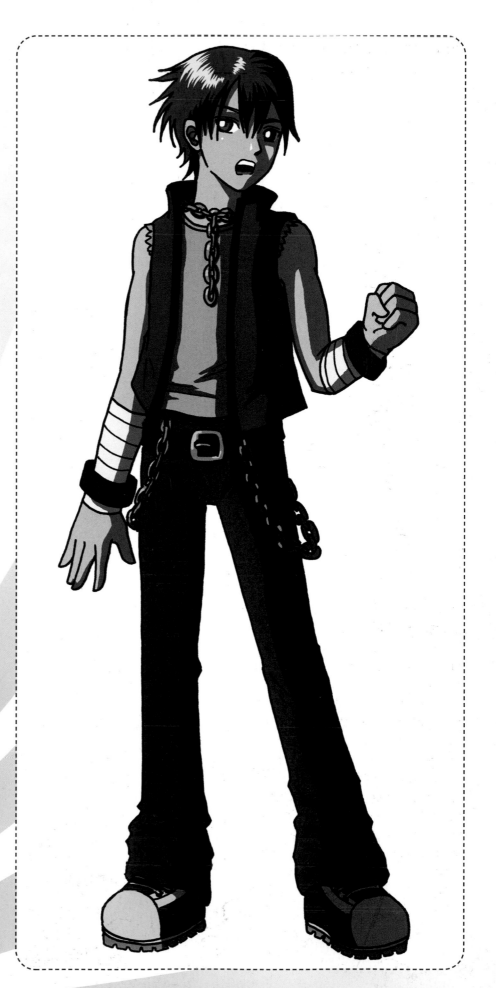

Teenage Male Alternative 1

This teenage character probably comes from quite an underprivileged background, but finds things in life to be compassionate about. The one hand in his pocket tells us that he has a real lack of regard for authority. He appears self assured and perhaps arrogant on the outside.

His schoolboy-mod style (pork pie hat and short tie) gives us a clue to his involvement in a sub-culture or underworld where his stories take place and the type of other characters, perhaps rough and shady, he might be affiliated with.

While his spiky hair and ill-fitting leather jacket have a definite punk sensibility about them, the limited colour palette used gives us the sense that he is in fact quite a refined and aesthetic individual. It also helps the character to appear designed.

We need to believe that he is tough and streetwise, but it is important to maintain that this is still our charming and charismatic protagonist. The reader needs to be fond of him. Chiefly, giving him soft and friendly features – large eyes and no lines on his face creates this notion. He also has strong eyebrows and a slightly comic expression.

Personality
Edgy, cynical, hard-nosed, compassionate
Setting
Contemporary, urban, seedy underworld, city

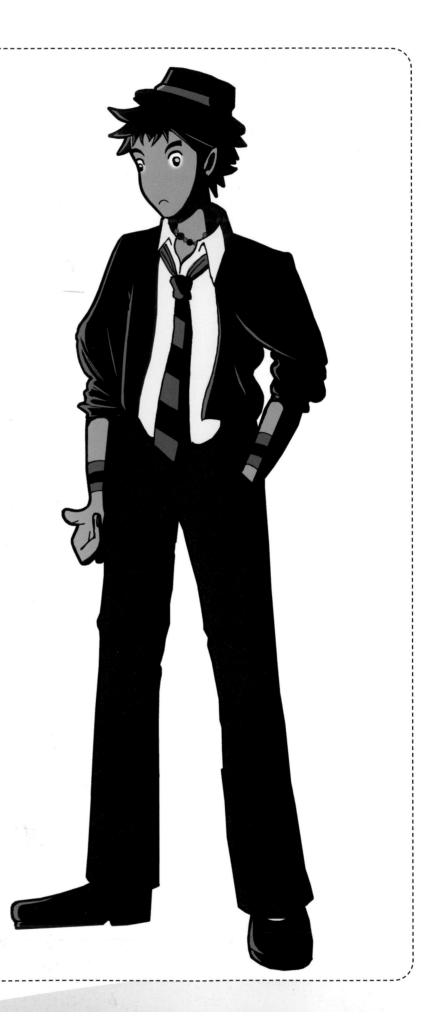

Teenage Male Alternative 2

This character is only four head heights tall as he is drawn in a very exaggerated cartoon style. His proportion set is very deformed: his legs take up 50 per cent of his entire height, his torso 25 per cent. His limbs are conical, which is unusual for semi-chibi characters.

He's a heroic character from the future who is very happy and optimistic. He has a very open, outgoing pose, which suggests that he is quite approachable, generous, eager to help and ready for anything!

The strong, bright colours reflect his good nature, reinforcing his character as a hero (this is in contrast to the duller colours usually used for bad guys or more angsty characters). Red shades make him appear full of energy or urgency.

Geometric patterns and stripes appear futuristic and sleek, and are an effective tool for adding volume to the character. His arms and legs have similar designs and patterns.

Personality
Enthusiastic, happy, brave, loyal, kind, selfless

Setting
Sci-fi, city, cybernetic laboratory, battles, action, adventure

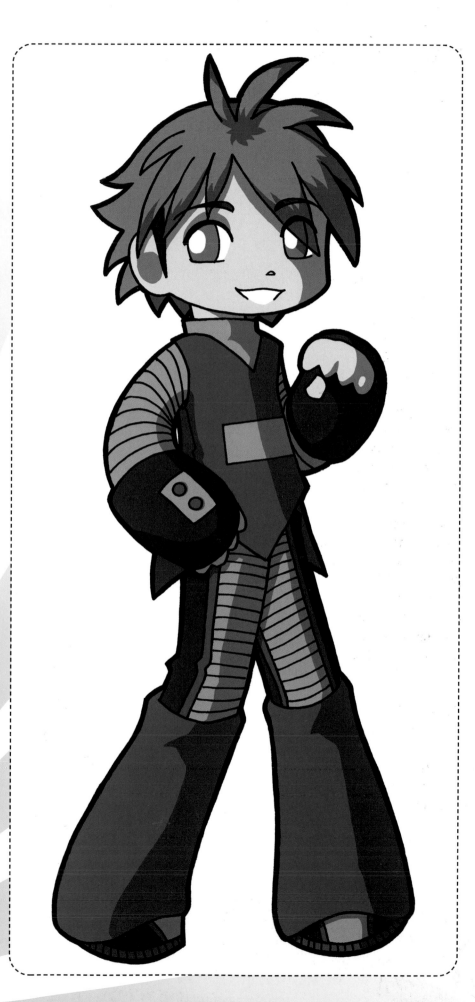

Step-by-Step Creation: Teenage Female

Immensely popular, attractive and appealing, the teenage girl is ever-present in anime and manga. She is beautiful to look at and still learning about life, playing an essential part in demonstrating the complexities of human emotion.

Rough Sketch ▼

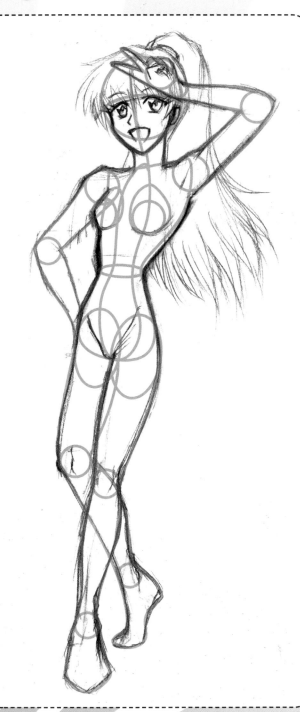

The teenage girl still has a rather child-like face with a body approaching that of an adult woman – however, her chest and hips will not be at their fullest. Remember that her overall proportions should be in the region of five–six head lengths.

When designing a teenage girl, it is particularly important to think about her personality because it is most likely to show out of all the characters. This girl is confident about herself and is fun to be around. Because of her positive outlook and friendliness her posture is very open – shoulders back and head held high. Her hair is tied back, she doesn't need to hide her face, giving a wide smile. Making a peace/victory sign, she enjoys posing for her picture.

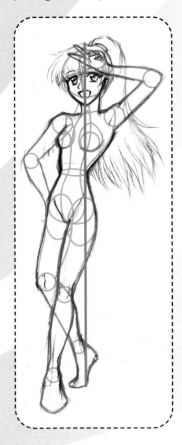

◀ *When drawing this pose, be very careful with her centre of balance. She is leaning back slightly, so one of her feet must be further back to take her weight. Draw the vertical line from her head to the floor to check that her right foot is correctly placed.*

◀ *Other possible facial expressions she could have.*

Adding Details ▼

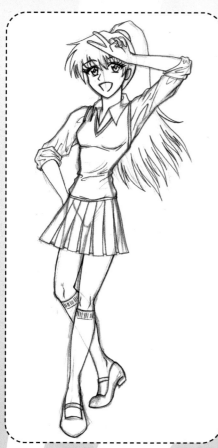

Inking ▼

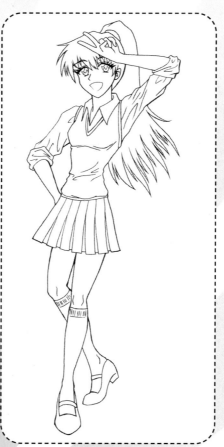

Basic Colours ▼

Because she is a modern-day teenager she is still in school, so she wears a school uniform of a short pleated skirt, collared blouse and knitted body-warmer. Her look is enhanced by the knee-high socks and dolly-bar shoes. Even though it is a uniform, she still brings her own touch to it – her sleeves are informally rolled up to her elbows. Don't forget to add folds to her clothing in areas where the fit goes from tight to loose, namely her sleeves, chest and waistline.

Clean up the lines carefully in the inking process. Some points to remember when inking:
- Include all the folds in her clothing.
- Lines like these should remain softer and finer than the lines that define real edges. The same principle applies to her skirt – the detail of the panelling of the skirt should be finer than the lines used to define the overall skirt shape.
- Make the ends of her hair pointed. Try to make your lines taper out finely so it adds to the flexible feeling of strands of hair.

Now start adding in the basic colours. Most school uniforms have a policy of white shirts, white socks and black shoes. Having determined those parts of her outfit, the remainder should offer a good contrast by being coloured. Bright and vibrant colours suit this girl's personality. Contrast the shading as well – her skirt is a dark green, but her body-warmer is a light yellow. To tie the whole image together try using the same colour or shade at different ends of her body; for example, her eyes, hair tie and skirt are all the same green.

Shading – Clothing ▼

Shading – Skin and Hair ▼

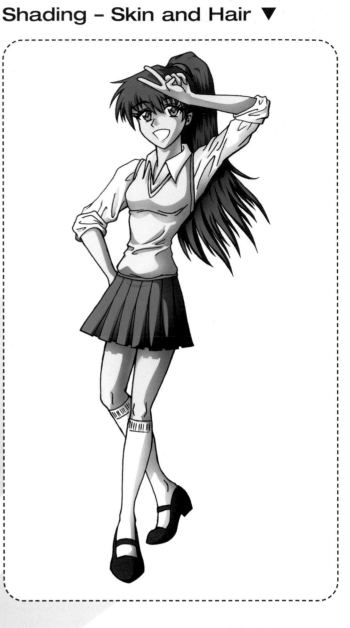

Once you have determined where and how strong the light source is, start shading in the appropriate areas using darker shades of the basic colours. This is a great opportunity to define and add to the folds in the clothing using shadows. Try to vary these shapes between sharp points and rounded curves.

For the shadows on her white blouse, don't be restricted to grey – try a light shade of colour. In this case, a light blue was used but other colours such as a pastel pink or beige could look just as good.

A warm, orange-brown suits this girl's skin shadows, matching her ginger hair. A reddish brown was used for the shadows on her hair. The shapes of the shadows really do lend themselves to defining the texture of the surface being shaded. Her smooth skin generally has gently curved shadows, whereas her hair has very thin long spiky shadows to emphasize the strands of hair.

Always bear in mind which objects are in front of the light source and which are behind. Her left hand is above her head, therefore her fingers cast a slight shadow on her hair.

When shading her skin, think carefully about the shadows her clothes cast. Note how the shading on her thighs matches the panelled hemline of her skirt.

Finishing Touches ▼

Bright highlights are mainly required for shiny surfaces. As her clothing is fairly simple and fabric based, her hair is the only area that needs this. Add highlights to her fringe, the top of her ponytail and near the ends of her hair.

Finished Image ▶

Personality
Outgoing, boisterous, genuine, confident, loud, sporty

Setting
Modern, school, shopping mall, comedy, romance

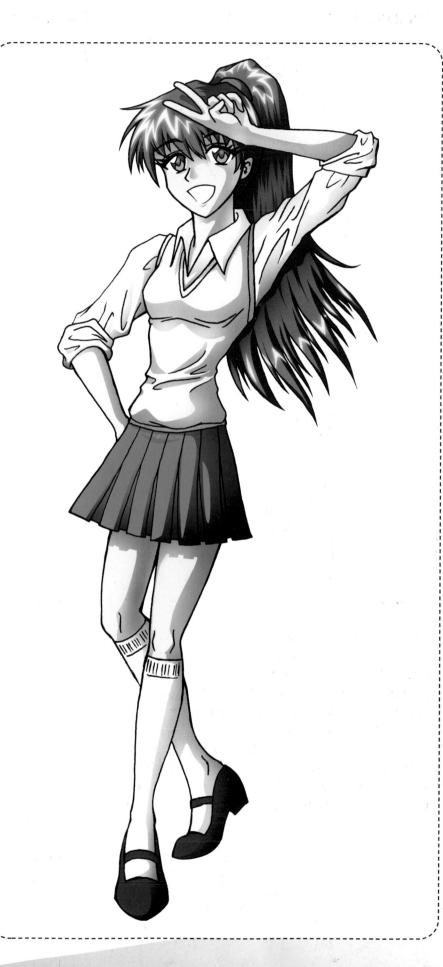

Teenage Female Alternative 1

This is a highly fashion-conscious modern teenage girl, dressing in the Lolita fashion. This style is worn by many young people in certain areas of Tokyo and is a popular fashion to draw in shoujo and gothic manga.

She is the correct overall height of five–six head lengths, but her head is oversized and her limbs and torso are very skinny. This is a contemporary art style, she looks almost toy-like. She still looks correctly balanced due to the fullness of her clothes and her chunky platform shoes. Her stance and the way she holds her bag is very feminine and elegant, with the girlish touch of her toes pointing slightly inward.

The girl is emphasizing her cuteness so her dress has puffy sleeves and full skirt, heavily accented with lots of ruffles, frills, lace edging and ribbons. These elements can also be seen in her hair piece, wrist band and shoes, tying the overall picture together. Take your time when drawing lace to keep the rounded ends evenly spaced and consistently sized.

Pink and white is a popular combination of colours to use in this fashion. Add lots of shadows to the cloth to bring out the ruffles and gathers. Golden locks and blue eyes match very well with her dress, alluding to the romance of fairytale princesses. Her glossy hair is due to the many levels of shading and fine white highlights, blurred slightly to soften the picture.

Personality
Quiet, dignified, sweet, polite
Setting
Shopping mall, garden party, café, gallery

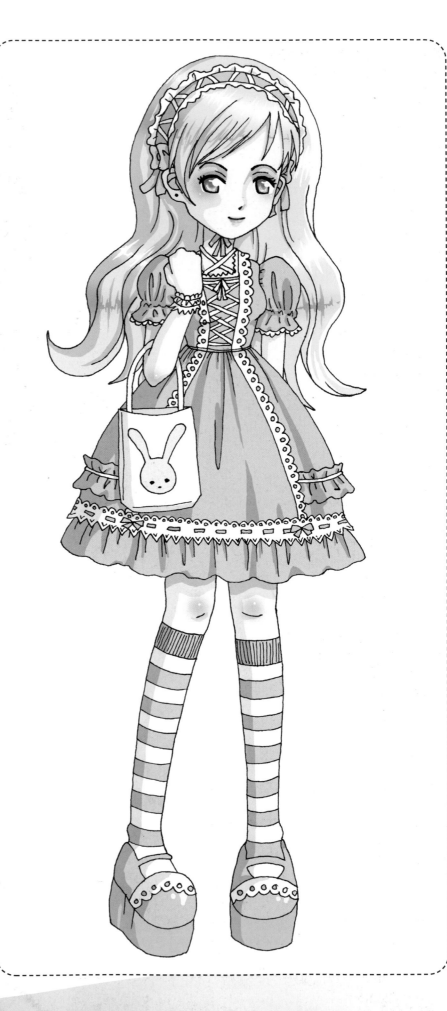

Teenage Female Alternative 2

In this image our teenage girl is a forest dweller from a fantasy world. Her practical costume is in a medieval style for ranging in the woods, but her unusually long hair and forehead symbol suggest an element of magic.

Her pose is self-assured and knowing. The way in which her hand is placed on her jutting hips expresses a quiet defiance. She's tilting her head down, yet looking up at us with the faint traces of a smile on her lips – a silent challenge, perhaps?

Her clothes are handmade from natural materials, therefore all the seams and stitches are visible, with many of the fastenings in the form of leather string. Note how there are leather ties on her boots, wrist and hair, creating a harmonious picture. Her hair is not elaborate, simply tied near the ends. Think about placement as well – her hair is blown in front of her slightly, so it flows over one shoulder.

Her entire colour scheme is natural and reflective of her environment. Forest browns and greens, very earthy. Her hair is a smoky red ochre, unusual yet very natural-looking. On her forehead is a spirit sign, possibly depicting her powers, status or role in a tribe.

Personality
Secretive, cheeky, independent, silent, insightful
Setting
Fantasy, historical, drama, adventure, nature, magic

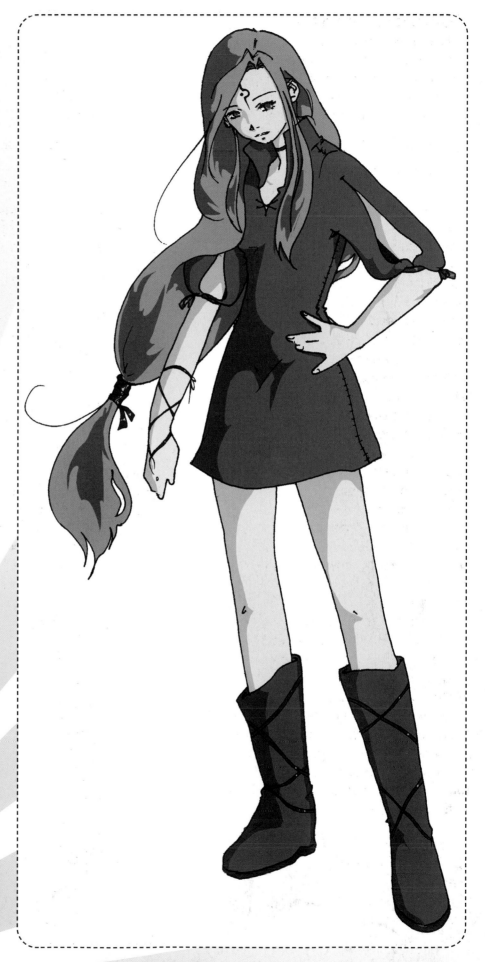

Step-by-Step Creation: Adult Male

Our standard adult male is around seven–eight heads high. Of all the manga character archetypes, he has gone through arguably the largest change. There was a time when he may have been forced into one of two stereotypes: the comedy/gag character, or the strong hero. These days the standard adult male is coming of age and has adopted a far more relaxed demeanour. The shoujo revolution has made an impact on his looks, and the need to appeal to both sexes has produced a character who is laid back, cool and quick thinking.

Rough Sketch ▶

As always, the sketch and ink stages have been used to ensure that the character's stance is befitting and natural. Our standard male is relaxed and so his shoulders are loose, hands in pockets. He is standing comfortably, both feet on the ground and the slightly cocked head implies that his brain is ticking over.

Figure ▶ ▶

As his height would suggest, the standard male is fully matured. His shoulders are broader in order to carry a larger chest area. Even male characters on the slim side will have a fairly broad chest and the shoulders must always be wider than the upper chest width.

Next, there will be a waistline band, though not as defined as that on a female. There are no hips to curve back out to and so the waist can fall lower. Don't be tempted to give male characters large hips. Unlike the female, the lower body shape of a man is defined by the muscles in his thighs and not by the hipbone. (Refer back to Figures and Proportion on pages 18–19 for a quick reminder.)

If we think more about how this character's personality is reflected in his pose we can learn a fair bit about him. As said before, his relaxed shoulders and pocketed hands could indeed make him appear casual and at ease. However, when combined with the sly smile and cocked head we start to get other ideas. It's almost as if this character has something in mind. He seems to be very observant; maybe some form of investigator. Or maybe he's just spied a girl who takes his fancy. Either

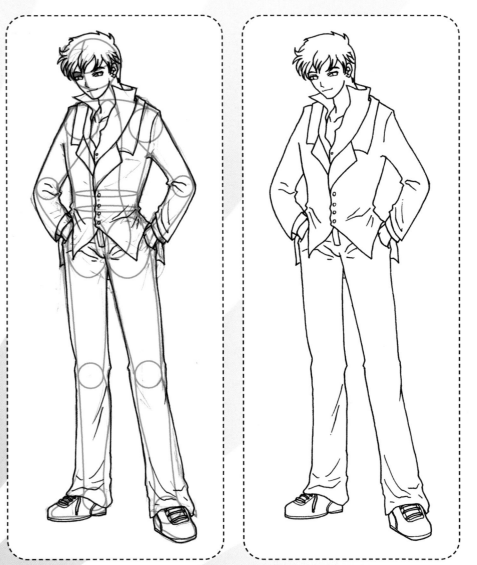

way, the combination of a casual pose with an active expression can provoke thoughts from an audience. Even if the pose isn't dynamic, the face can be.

Turning to our standard male's attire our instant thought is that he likes to dress the part. However, when we look a little closer we can see that the suit he's wearing is quite ill fitting. Adding extra wrinkles and creases to the fabric shows the excess material of his suit. These have been added especially around the areas where the jacket and trousers would naturally crease; namely the elbows, groin and ankles.

◀ *Here are some alternative expressions he could have.*

He is wearing a retro-style shirt with its collar turned up. This suggests an element of secrecy and mystery when coupled with his thoughtful expression.

Then of course we have his highly unlikely shoes! What do these suggest about his character? He either wears these shoes out of laziness or maybe the need to move fast when the time calls for it.

Basic Colours ▶

Because our adult male is wearing a standard suit, the likely colour is a dark one as chosen. Where the personality shows through is in the choice of shirt. On a design level this bright pink shirt really lifts the dull colour of the suit. On a character level it speaks volumes about this man's attitude – he's fun, not too worried about being obvious and quite an extrovert.

This unusual colour choice is also reflected in his trainers. They manage not to suit anything in his outfit. Again suggesting that he's not too worried about fashion or appearance.

The skin colour chosen for this image is quite pale. This man is not the outdoors type and so his skin is not tanned.

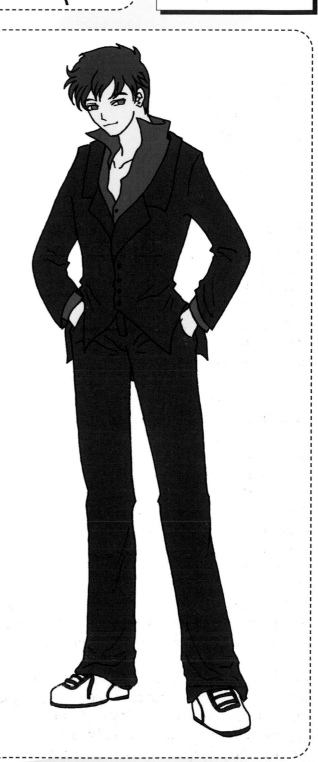

Shading and Highlights

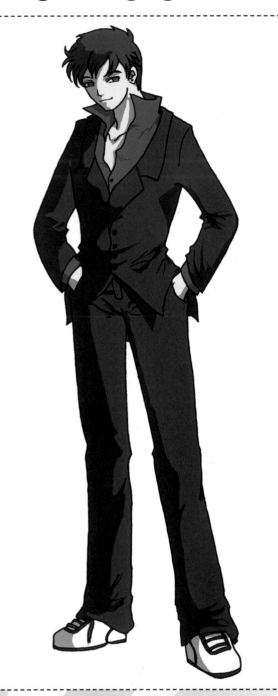

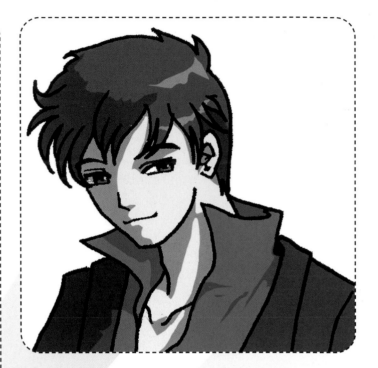

▲ There are very few highlights in this image. The fact that the eyes are half closed means that less light would be reflected and so, even here, very little highlight has been added. The slight areas on the hair serve to show further where the light source for the image is.

▲ Quite large areas of shade have been used on this image. This adds to the element of mystery in his character. Our light source appears to be somewhere above and to the right of the character. Remember that the heavily creased areas will become especially shaded, as the folds will not allow light through. Though the jacket conceals the frame, shade can be used to define areas such as the chest. By bringing in the line of the shadow, details like the waist and knees can be emphasized even in a heavy piece of clothing like a suit.

▲ *Adding an unusual element to an otherwise standard costume design is an easy and effective way of engaging a reader. Any element of design that can make the observer ask questions is useful in building a character. These trainers contradict the character's entire outfit and lead us to wonder why he chose to wear them.*

Finished Image

Personality
Quick-witted, dry, intelligent, playful
Setting
Nightclub, casino, bookmakers, detective

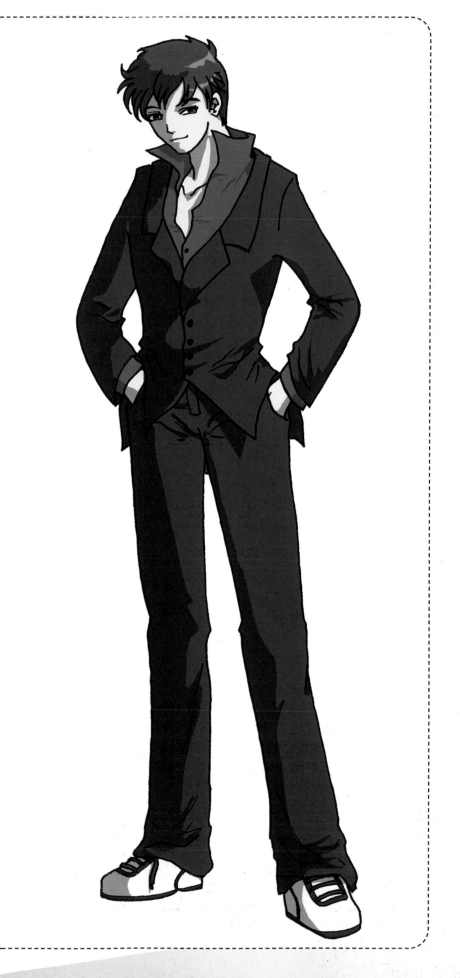

Adult Male
Alternative 1

A traditional samurai warrior with a twist – with his silver hair and indigo eyes, he doesn't exactly seem all Japanese! His true origins are shrouded in mystery. He looks to be a serious type, a man of few words. You can bet his skills with a sword can do all the talking for him!

He is wearing very traditional Japanese attire – a happi/kimono-like top, hakama trousers and geta sandals. His hairstyle and katana sword are also authentic, in keeping with the historically accurate design. Also common in manga and anime, his top is hanging off one shoulder – it gives an air of self-assurance and skill.

His robes have lots of thick folds to make the fabric look heavy. Take particular care when depicting his musculature as it is fully on show! Practise drawing thin lines to hint at folds and muscles, and thick lines for true outlines and breaks between clothing to enhance the three-dimensional look of this piece.

The colours for his costume are traditional and realistic, so to contrast his hair is a silvery tone. It contrasts nicely with the heavy black line work and complements the other colours. The character's eyes are also not a traditional Asian brown, but an intense blue/indigo shade, making him look more mysterious and enigmatic.

Use clean, sharp shadows to emphasize the folds in his clothing. Add soft highlights to his hair, sword scabbard and chest.

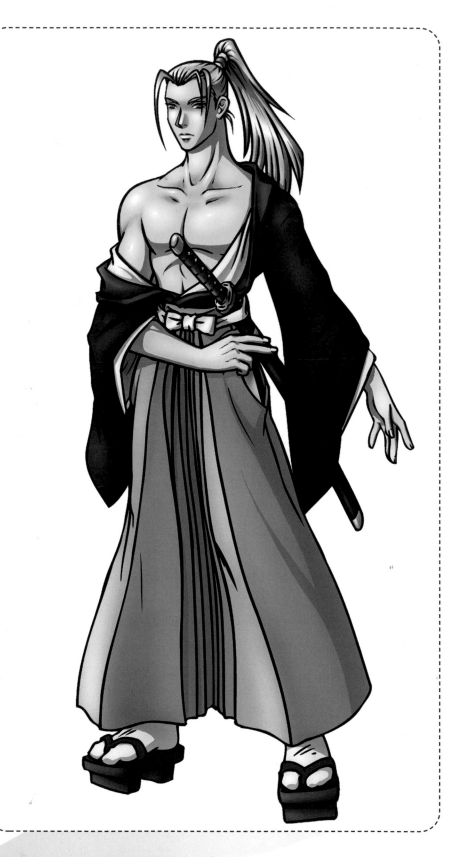

Personality
Strong, silent, intelligent, analytical, honourable
Setting
Japan, historical, action, romance, temple, duelling grounds

Adult Male Alternative 2

When creating an adult character, it's important to consider what could be done to make them appear more mature without being too stuffy or boring. This man is definitely not boring – his expression, clothing and pose all point to a character with lots of attitude.

Using an exaggeratedly tall adult proportion set with tightly defined muscles and bone structure gives him a strong presence and helps to distinguish him from younger, teenage characters. Heavily defined facial features are also important to make a character appear adult, with eyes drawn smaller and much stronger definition of the neck and cheekbones, with chiselling common throughout.

A character such as this presents an air of experience and confidence, as he stands bold and fearless with a knowing smile. Although he is youthful and jokey, subtle details such as the slight squint in his eyes and his firm grip on his pole-like weapon give the impression of someone not to be crossed.

Sometimes colouring can look very effective without filling in entire areas – the colour of his skin is depicted using only coloured shadows. His clothes are not only coloured, but textured as well. Don't forget the small, detailed accessories such as his yellow-tinted sunglasses, his shiny metal dog-tag necklace, and the buckles and lacing on his chunky boots.

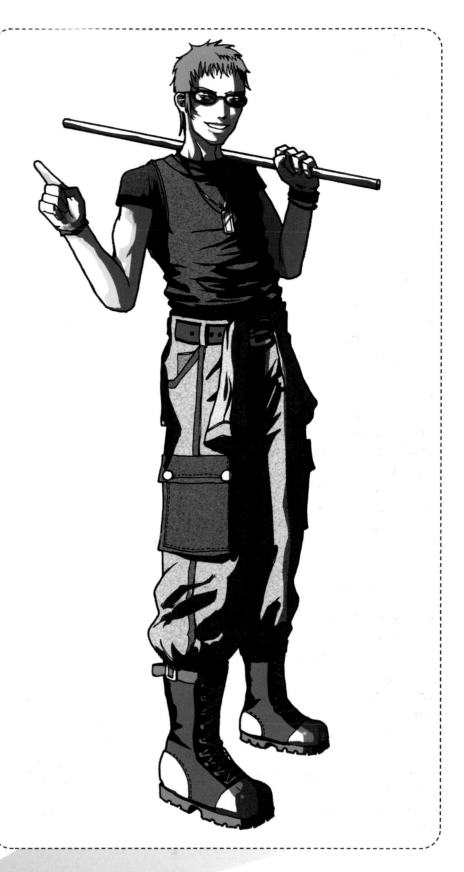

Personality
Strong-willed, witty, streetwise, independent, casual, cool
Setting
Modern, action, fights, gangs, street, shopping mall

Step-by-Step Creation: Adult Female

A common character in young women's comics, the adult woman has life experience but retains the fun-loving years of her youth. With many roles in the world of manga, from a big sister icon to a hardworking office type, she is very versatile – supporting the main character in various storylines, as well as being a very interesting and capable character in her own right. In Japan, many young women read manga which is similar in design to fashion illustration. The themes can range from edgy to contemporary to amusing. Therefore a character that can convey many expressions is very desirable.

Rough Sketch ▶

This lady is feminine, but confident. Sketch out a basic skeleton and action line to give her a relaxed pose. She has a less babyish face than a teenage girl, while still retaining wide pupils to show her friendly and welcoming nature. She can be as curvaceous or as athletic as you like. Her proportions here should range from seven–nine head lengths tall when using the usual guidelines.

Adding Details

The hairstyle depicted here is a shoulder-length, straight, layered cut. She has strands of a fringe over her face which implies she is sensible but has a fun edge to her nature. She wears simple yet plainly visible accessories; big hoop earrings, a large shell disc choker and thin bracelets on each arm. Her handbag aptly matches her summer sandals.

The loose way she holds her handbag in the other hand implies she may have a gentle aspect to her nature. Her feet are placed slightly apart which is, unconsciously, a positive, self-assured stance.

Perhaps she is not even an office worker, but a student or a mature student. She is possibly a gym-goer, therefore she may be a little body-conscious but can get away with wearing tummy-revealing summer clothes. Her skirt is knee-length and casual; her clothes are fun and fashionable but not in an overtly sexual way, which shows this character is fun-loving and good-natured.

◀ *A range of facial expressions that suit this character.*

Inking ▼

Basic Colours ▼

When inking, it is best to try and remember all of the following points:

- Her hair is layered and choppy; remember that manga hair strands always taper to a sharp point. Her strands are quite thin and fine; the longer the hair, the sleeker this effect should be.
- Place folds and creases accurately and realistically – look at fashion magazines and photos to get a better idea of where creases and folds fall.
- Details like folds and clothing detail can be inked using a finer pen, tapering out to thin lines.

This character is wearing summery clothes that would not look out of place on the beach. The darker tones of the brown skirt and the warm orange top are contrasted slightly by yellow details and the characters' blonde hair.

You may like to experiment with skin tones; if this character has been sunbathing she should have a slightly darker skin hue to show that she is tanned.

For consistency, her brown eyes match her skirt and the soles of her sandals; her orange top matches her orange bag etc. Her accessories are a neutral colour which complements the character's dress sense.

Shading ▼

Highlights and Finishing Touches ▼

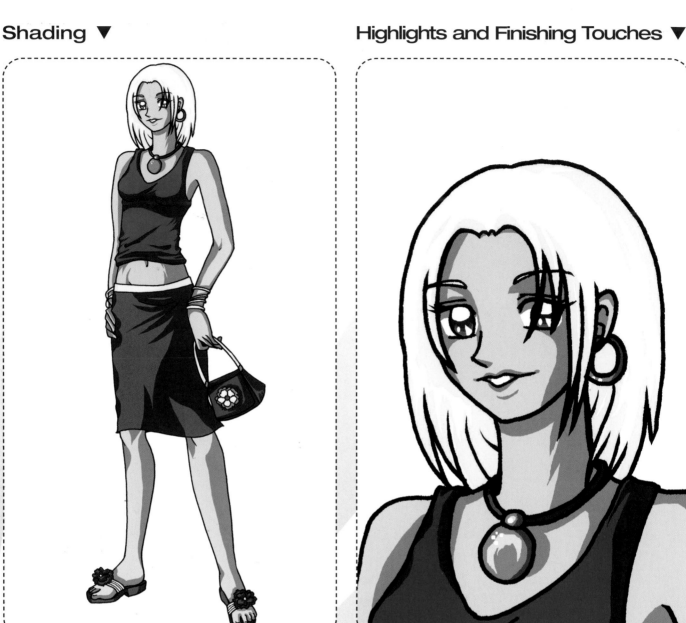

Choose where your light source is appearing from. Then make sure you add shadows in the appropriate areas of your character; her skin, her clothes, her hair. This is done using a deeper shade per colour used.

You can emphasize the creases and folds by adding and elongating tapered shadows; this is prevalent in the detail used on this character's top at her bustline, near her waist and also where her hand is holding the bag by her hip. These shadows are quite crisp and pointed; you can alternatively use a softer brush to create softer shadows.

If possible try to match the shading of the clothes your characters wear with the shading on their skin – note the shadows on her right knee. This adds a consistency to your art. There is more shadow on her skirt on the right-hand side as it is angled away from the light source.

The clothes this character is wearing are made from soft fabrics, even her shoes are made from fibrous materials, so highlighting is not required on her top, skirt or sandals. As it is summer she's carrying a canvas bag, so highlights won't be needed here either. Highlights have been added to her shiny jewellery and her smooth hair, although being blonde the highlights may not show up unless they are very light or pure white.

Finished Image

Personality
Fun, outgoing, bubbly, hardworking, confident, determined

Setting
Office, university, pub/bar, shopping mall, lecture hall, coffee shop, bookshop

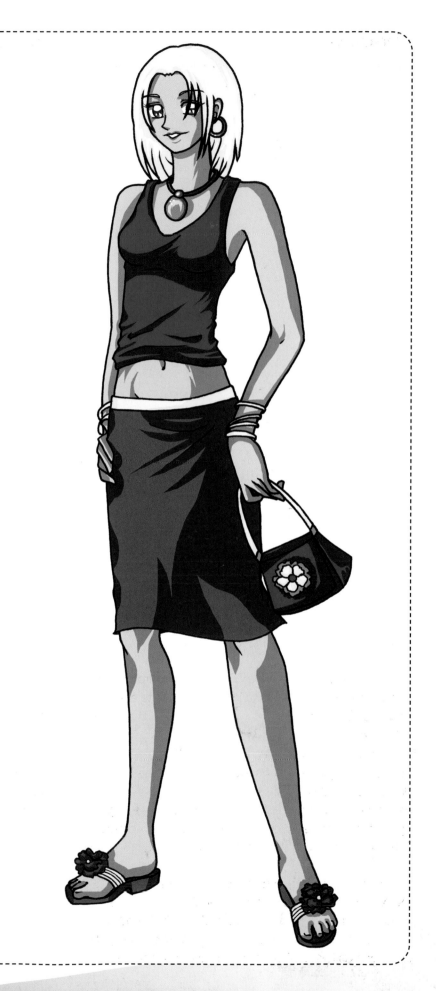

Adult Female Alternative 1

This future woman has just removed her helmet to take in her new surroundings. She is a character that could easily fit into an epic space opera.

She knows she's sexy, making the most of her figure in a tight-fitting suit and by the way she is standing. The details and design of her clothing are futuristic, made of non-fibrous, artificial materials and metallic sections.

It is the colouring of this picture that confirms the other-worldness of this character. Although she is not old, her hair is white, indicating how different she is from us. The cool colour scheme reminds us of the sky and of space, much more appropriate for a space huntress than browns or greens.

The shading really helps to define the materials of her costume – bold, contrasting base colours, shadows and highlights give her clothes a lot of shine. Look at the metallic areas carefully – start with white leading to light greys, then use a bold streak of dark grey, interspersed with mid-greys. Take particular care with her helmet as not only is it reflective, but also transparent.

Her calm eyes and wry smile indicate lots of life experience – you can imagine her sighing and rolling her eyes if something annoys her, particularly if it's something she could have easily dealt with. She looks like someone who will work hard to get a job done, then relax and enjoy herself later.

Personality
Calm, knowledgeable, tough, cynical, independent

Setting
Space station, spaceship, alien planet, future, comedy, adventure

Adult Female Alternative 2

A dangerous woman, this lady is someone you wouldn't want to cross. She strides purposefully towards us, brandishing her sword; beautiful but deadly.

This character is a modern-day Japanese warrior, wearing kimono-style dress with some contemporary styling complementing her sheer stockings and tightly-worn hair. The sword is relatively simple but perfectly matched to work with the costume, along with the matching scabbard. Note the use of very thin, subtle highlights on her stockings, belt and hair.

Although she is obviously very sexual in nature, due largely to her figure and revealing outfit, the character's pose and expression is completely focused forward without a hint of a smile or a wink. This gives the character a very real sense of purpose and role rather than a mindless character merely dressing-up and posing for a photo.

Adult female characters have some distinctive differences to their teenage counterparts. Even with young adults, the physical development shows the difference between women and young teenage girls. A heavy hourglass figure shows off the character's bust considerably, but also draws attention to wide and developed hips. Adult characters tend to be more experienced with their role as well, reflected in the manner of this swordswoman.

Personality
Focused, cold, impersonal, ruthless, experienced

Setting
Japan, city, club, street, night, horror, present, thriller, action, gangs, Yakuza

Projects from the Masters: Watercolours

Tools

Brushes
Set of watercolour paints (tubes or pans)
Water pot
Scrap paper
Watercolour paper
Black waterproof ink
Paper towels
Cloth

Preparation

Watercolours are a very traditional choice for illustrations. They can create a range of effects, but are difficult to control at first and can be unforgiving to use. For the best results use specialist paper to prevent any wrinkling. Clean your brushes well and test out your shades and mixes on a scrap piece of paper. Be prepared to work fast when trying techniques that require wet paper, and be patient when allowing paint to dry.

Pencil and Ink ▶

Ink your picture with a good black waterproof ink. If you're unsure about the permanence of it, test the ink on a sheet of scrap paper first. In this image, only the character is inked; the background is left in pencil for a more subtle effect.

Skin ▶

The skin is painted light to dark shades. A very light flesh coloured wash is applied as a base. After the paint has dried, shading is slowly layered on top. Each area is painted one at a time and when each one is done, the brush is washed and dried so there's only a little water on it and the clean brush is run along the edge to soften it.

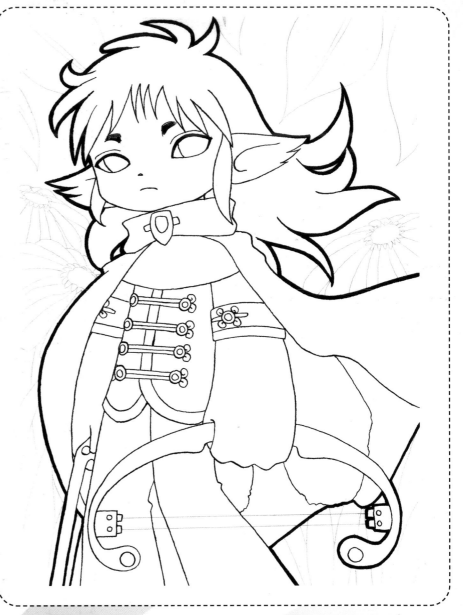

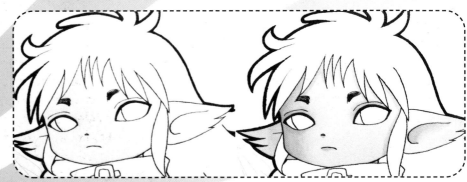

If your character has dark hair, it's advisable to paint it before the skin. If you make any mistakes or go over the lines a little, it's easier to clean up if the paper hasn't already been painted.

Cloak ▼

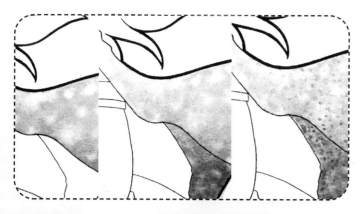

A wet wash of green is painted and watermarked by dripping clean water into the still wet paint. When the base colour is dried, looser, messy washes are applied in yellow and blue on top to give the colour more depth. Small dots of paint in different colours are dabbed onto the page, giving the cloak a sparkly, mystical look.

Wings ▼

A wash of ochre is applied and watermarked in a similar way to the cloak. The centre of each watermarked dot is lightened further by lifting the wet paint off with a paper towel. The same technique is used again, on top, with orange. Then a wash of clean water is used and more orange paint is dabbed and blended into it to bring out the darker areas. Brown is dotted on the tips of the wings as a final touch.

Clothes ▼

The clothes are painted with the same method used on the skin. On parts like the shirt and trousers, a bolder colour is used as a base (red and ochre respectively), then brown shades are layered on top to create the exact shade required.

Background ▼

The background is painted simply with flat colours first. More colour variation is introduced through layering different coloured paint on the grass. The tips of the flower petals and the leaves are shaded with a soft, light gradient, and green and blue shading is introduced to the sky for more contrast.

Hair and Finishing Touches ▼ ▶

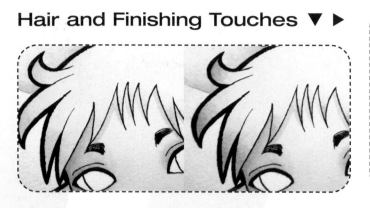

The hair colour is blended from the white paper, through ochre and to orange at the tips. The eyes are painted last to better complement the shades used on the rest of the character. Highlights are added in white ink on the strings and gem (gouache and acrylic are great for the same purpose).

Finished Image ▼

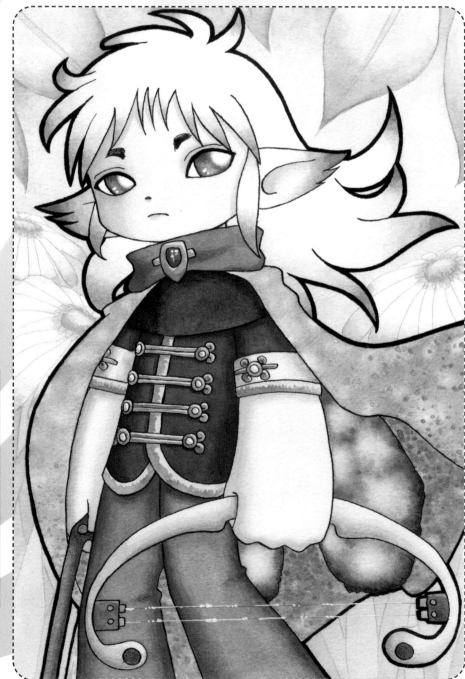

Master Tip: Fixing mistakes

If your paint goes over the lines a little, you can fix it by quickly dabbing it with a paper towel. For strong colours, you may need to dilute the paint a little before it will come off completely, so use your smallest brush and a little water to gently thin and lift off the paint.

Watercolours Alternative

These characters were created with a retro manga theme in mind! The soft colours and limited palette mean that the texture underneath the pigment helps lend simplicity to the cuteness of the image.

The picture was sketched out using a light coloured pencil. The different areas of the picture are block filled using a small amount of pigment with the paintbrush half-loaded with water. The pigment was shifted around each area with a flat brush. A 1cm/⅓in wide brush with a rounded tip was used to indicate the shadows. The image was left to dry in between using each new colour.

Areas of grey shadow are added only to the white parts of the picture to ensure they don't blend into the background too much. Finally, when dry, the character was outlined with a brush pen using a soft brown ink.

The characters are very rounded and cute; the little girl is obviously enthralled with her new-found magical rabbit!

Projects from the Masters: Coloured Pencils

Tools

Coloured pencils in baby pink, lemon
 yellow, honey yellow, orange, burnt
 amber, red, lilac, maroon, purple
Pencil sharpener
Piece of Bristol Board (220gsm
 smooth artists' paper),
 210 x 297mm (8¼ x 11¾in)
Plastic eraser
Craft knife (optional)
White ink or white acrylic (optional)

Rough Sketch ▶

To begin, choose a very light colour
such as baby pink, to delicately
sketch the outline of the figure. If you
do not feel confident putting pencil
immediately onto the board, try
roughing out your design first on a
scrap piece of paper to practise
your strokes.

 The outline should only cover the
major shapes of the drawing, not
finer details which can be added
later. So concentrate on the size and
ratio of the character, his or her
pose, and the positioning of the
character on the chosen page.

 Always have a pencil sharpener to
hand when sketching to add fine
points of detail. You can slice off
parts of a plastic eraser to get very
fine edges and points to erase-in
minor highlights accurately.

Face and Skin Tones ▼ ▼

Continuing to use baby pink, start pressing harder on the outline of the character, pressing more softly in areas where
light will fall on the character. Concentrate initially on the skin tones. Remember that the light will fall in the same
direction all over the character. In this picture, the light source is falling directly onto the character, straight on. You can
concentrate on the three-dimensional aspects of the character's face by darkening where shadows fall behind raised
areas, such as the area behind the nose, cheeks, knuckles and so on. Highlighted areas can be rubbed out using a
rubber eraser, which picks up coloured pencil nicely without leaving dirty smudges on the paper. Build up the colour
range by adding marks in different colours, such as orange, burnt amber, red, then lilac.

Dress ▼

To complement and contrast purple shades, yellow is used for the main dress colour. Again, press harder on the outlines of the dress in this colour, then slowly colour in the dress using a mix of lemon and honey yellows. Don't forget the direction of the light. Darken the creases of the dress by using ambers and reds. The ruffled lace edging on the dress straps is brought out by the addition of darker colours.

Hair ▼

Colours used here are lilac, maroon and purple. Start by gently colouring in the main areas of the character's hair, leaving areas of white where the light would fall. Then by pressing harder, start marking in darker areas which will help make the hair look more three-dimensional. Shade in areas behind other strands of hair so that the hair looks textured and full. Continue by adding layers of strokes in darker coloured pencils.

Finishing Touches and Details ▼

Purple, the darkest colour, is finally used all over this character to define the darkest area of shadow and to also help define the character. Without this contrasting colour the character would easily blend into the background, losing the focus of the image.

The eyes have been drawn using honey yellow for the main part of the iris, with a darker shade of maroon. The pupil is a small dot drawn with dark purple. A bigger pupil can be drawn to make the character look friendlier or younger. To depict highlights in the eye, ideally you should leave an area of the paper white. Alternatively, use a plastic eraser to rub out a small highlight from the pencil or dab white ink or acrylic on top. Eyelashes have been drawn carefully using very dark purple – eyes hold a lot of character, so they are deserving of a lot of time.

Lips and details such as earrings and hair-bobbles have also been drawn in the same style; a lighter colour on the inside, a darker colour near the top, a reflective bit of light left in, a darker outlined area to define the shape of the detail.

Lemon yellow is in high contrast to purple, used to highlight a few surfaces which catch light. This may be a slightly unorthodox colour scheme but the contrast helps give the picture a unique edge. This is particularly effective in portraying different-coloured light sources and back-lighting.

Background ▼

▼ Finished Image

As the character is quite detailed, a simple background is recommended. Too much detail will make the picture messy and busy, whereas no extra detail will make the picture look too plain and unfinished.

A picture reference of a rose was used and the same colours – baby pink and purple – were also used to match the colours in the main image.

Using the reference, the pattern of the petals unfurling was recreated by lightly sketching the petal pattern in baby pink. The focal point of an unfurling rose is its centre. This was placed near the character's clasped hands so that it would be easily visible but not impose upon the main focal point of the character – her head and eyes. One by one the petals are drawn. Areas of the flower where the petals curve and bend are emphasized by a darker shade of the same colour.

Try changing the combinations of colours for different effects. Keep your pencils sharp and don't be afraid to start a picture again a few times or to rub out lines which initially don't feel right.

Coloured Pencils Alternative

As well as creating very delicate, subtle coloured images, pencils can also be used in very expressive or minimal ways. You can create quick, bold sketchy images by building up lines of different colours. Start with a very light, almost white, shade, and sketch the basic composition. Build upon this sketch by fleshing out the details in successively darker shades of pencil. Save the darkest shade for the areas you really want to accentuate – like eyelashes, tips of hair strands, and any other small details.

Create interesting pictures by layering hues. For example, start drawing in yellow, then build it up through orange to red. Using completely different colours instead of similar shades creates a much more dramatic effect.

Try to be quite abstract when choosing colours for sketching. The colours you use just have to work together, they don't have to literally represent the person or object you're drawing.

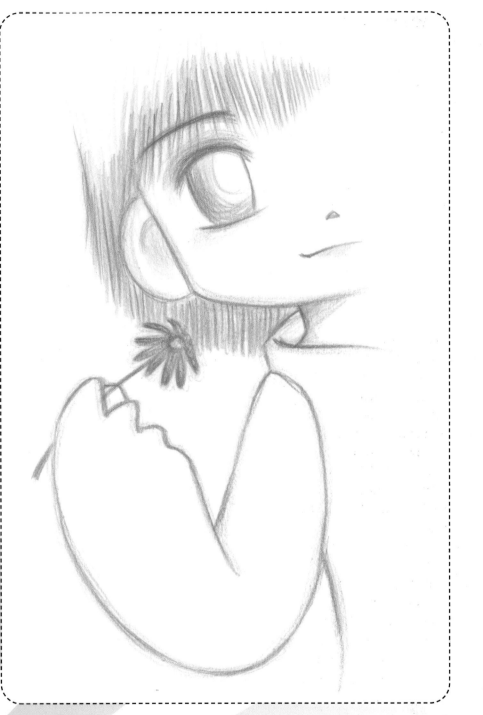

Projects from the Masters: Coloured Markers

Tools

White printer paper or Bristol Board
 (220gsm smooth artists' paper)
HB or softer pencil
Eraser
Permanent fineliner pen or
 photocopier/laser printer
Range of coloured markers

Preparation

Before using markers be aware of the way in which they work on different surfaces and how they affect your line art. Unlike the usual felt-tip marker pens for sale in stationery shops, professional coloured markers generally have alcohol as their base, resulting in an incredibly even distribution of pigment.

Use your markers on smooth surfaces that can handle medium amounts of liquid. Plain 80gsm printer paper works surprisingly well with adequate padding underneath. A more expensive alternative is Bristol Board, a thick card with a smooth drawing surface.

Because the markers are alcohol-based, you need a very resilient ink to avoid smudging. Test your pen's capabilities on a rough piece of paper. Specialist pens are available to buy, but are quite costly. Another way is to photocopy or print out a copy of your line art. Some copiers and printers use heat-bonded toner powder which is completely resistant to alcohol-based markers. This also means you can create several copies to use for practice, or as a backup if you make any mistakes.

Pencil and Ink ▲

Sketch your picture gently so as not to mark the paper, then ink when you are satisfied. Consider the style in which you will colour – this picture is intended to have very detailed, fine strokes and soft blends, hence wispy hair and fine lines are appropriate. Try to create imaginary sections to colour in bit by bit. For a completely streak-free finish, you must always keep the ink edge wet whilst colouring – small sections are much better for this than large expanses of space to fill.

Master Tip: Avoiding streaks

Always keep the ink edge wet. Overlap your brush strokes whilst keeping a consistent direction. Alternatively, outline a section and then work your way into the middle by going around in circles.

▼ Skin and Hair – Layering

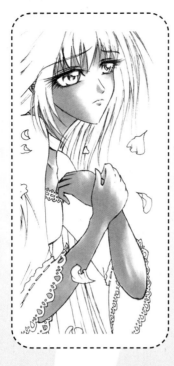

Start with the lightest tone the skin could be – in the woman's case her cheeks were left uncoloured because she is so pale. Strokes are soft and feathery – lift the tip of your marker gently off the paper. Shadows are added with the same pen several times over for a soft blended look. You can also use a slightly darker shade.

Hair is wonderfully represented by long, tapering strokes, adding to the texture. Light shades of hair can be depicted with just one marker shade – leave highlights white and darken shadows by layering the same shade over and over. Darker hair may need two or more different markers. The man's hair is coloured with a light brown shade. Then, using a darker brown, shadows and edges are added. You can use the light brown to colour over and soften the edges of the dark brown.

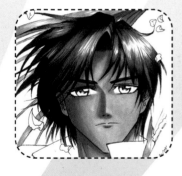

▼ Eyes

Eyes are a great opportunity to make colours bleed into each other. Put a dark shade near the top of the iris, then whilst wet, dab a lighter (contrasting, if you're brave) shade at the bottom of the iris.

Master Tip: Light and dark

It depends on the look you are trying to achieve. If you want bold colouring where shadows are clearly defined, start with a light, all-over base and add shadows when dry. If you want to create soft blends, start with the darkest shades and layer over lighter colours whilst wet.

Cloak ▶

Practise this on a rough piece of paper before using on your actual artwork. For the best blends, you must work from dark to light. Draw in the shadows first, with feathered strokes where needed, then add lighter greys over the shadows in many layers. Make an effort to work quickly, as wetter is better!

◀ Dress

To give the impression that her dress is made out of a plush velvet material, use the pointillist method – marking in lots of little dots. To make the change of colour gradual, use the light green repeatedly until it appears dark enough to blend into the shadows, at least five or six layers.

Whites ▼

You should only need to colour in the shadows of any whites in most lighting situations. Greys work very well for shadows under neutral lighting, but you can also use very pale shades of blue, green, pink or yellow to match with the rest of the colours in your picture.

Reds ▼

Red is used as a colour to tie the whole picture together, appearing in the gentleman's neck-tie, the lady's choker, ribbon lace detail on her sleeves, and in the rose petals fluttering through the air. Take particular care to keep dark colours within lines.

Finished Image ▶

Stormy purple clouds complement the colours used so far, and provide a suitable contrast against the lady's light brown hair. Working from the bottom up, start with dabs of dark purple and make the colours bleed and spread by adding lighter purples. Gradually stop using the dark purples, and rely instead on layering the light purples over and over until you obtain an appropriate shade. Use a blender/solvent pen liberally to make the colours run.

Coloured Markers Alternative

Because markers have great colour consistency, they can be used to easily create simple, effective flat coloured images. The lack of complex soft colouring means flat coloured pictures rely more on the design aspect to keep the composition interesting and eye-catching. Good colour choices are also important, but as there's little or no lighting you can be as abstract as you want.

When colouring with markers in this style make sure there is enough detail in the drawing to prevent it looking sparse and empty. Even if there are few colours on the background, detailed inking helps the image look complete. Also, the added detail helps avoid streaking, usually caused by the edge of the marker inks drying, which more frequently occurs when there's a large area to colour. Streaks and blemishes show up more obviously on flat coloured pieces, so it's especially important to try to avoid any problems.

Try using flat colouring on tinted or marbled paper for interesting effects. Because marker inks are transparent, the colour of the paper will show through the markers, creating atmospheric images or adding interesting textures to a medium that often has virtually none.

Projects from the Masters: Pen and Ink

Tools

Pen with nibs of differing widths
Bristol Board (220gsm smooth artists' paper)
Fineliners
Brushes
Pot of ink
Pencil
Eraser
Rulers and French curves
Correction fluid

The moment an image is inked is when it takes on its true form. Without the veil of indistinct detail that pencil work or sketches can offer, inking makes completely apparent where each and every line on the illustration should be. Inking is also the point where an image can go from seeming amateurish to being a polished and professional commercial manga image – ready to be reproduced in print or on the web. Taking time over inking can make all the difference to the quality of your final work.

Sketching out the Bike ▼

Firstly, the image of the girl on the bike is sketched out. Built up originally from light lines, darker lines are placed so that the inking can be done neatly without too much guesswork. Particular attention was made to the details of the bike to ensure accuracy, knowing these would be defined clearly in ink. For this image the paper size used was relatively large, approximately 300 x 400mm (11¾ x 15¾in). This is so that enough detail could be achieved with the inking, and so that small inaccuracies would be reduced when the image is reproduced at a smaller size. Bristol board was used because of its smooth surface and ability to hold fine detail without feathering.

Master Tips: Inking

• *Don't be afraid to make mistakes*
Correction fluid and white-ink is available to amend errors in inking, so be sure not to stifle your inking with concern about errors. It's important to move the pen smoothly.

• *Use a ruler*
Using rulers, French curves and templates ensures lines are as neat as possible.

• *Avoid smudging*
Remember to use a ruler with a bevelled edge away from the paper surface so the ink doesn't get caught between the ruler and paper. Also, be sure to give areas of wet ink some time to dry. If you've worked on an area for a while, perhaps work on a different part of the image to give the first part time to dry.

• *Rotate the page*
One of the biggest advantages of working with ink on paper is that you can rotate the page and make the most of the limited arc of movement within a human wrist. Be sure to rotate the page often to ensure the smoothest pen strokes.

• *Ignore your sketch sometimes*
If you think you can draw a detail neater than you have in your sketch, then go ahead and do so. This applies particularly when drawing patterns or repeated parts of a design, as each piece should be as precise and accurate as possible.

Inking the Girl ▼

Inking the Bike ▼

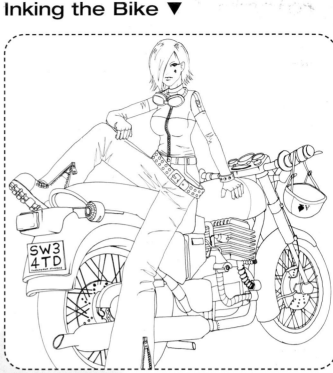

The lineart for the girl is done almost entirely with a single size of fineliner, in this instance using a fine 0.1 nib. Some face features were done using a 0.05 nib, but the difference between these nibs is actually very subtle and only visible on certain paper types. Particular care was taken over detailed areas such as the boots and zips of the clothing on the girl. These solid and mechanical parts have to be rendered neatly in order to come across as believable. Notice the horizontal stripe detail on the girl's top and the tops of her sleeves. Lines and geometrical patterns such as these along the surface of the body help to define the volume of the object, even without shading.

Larger pens were used for the bike, taking the size of the bike into consideration compared to the girl. 0.3 pens were used for the majority of inking, but 0.5 pens were used in some areas. Rulers were used extensively to maintain a mechanical look for the parts of the bike, and a French curve ruler was used in order to allow the curved bodywork of the bike to be neatly drawn with a single line. When inking machinery it's especially important to be neat, as wobbly lines become quite obviously inaccurate to the viewer. At this stage, the image would be perfect for any number of purposes. It could be coloured with markers, paints, computer or even have screentone applied. However, for this project the image is done entirely with black ink, introducing some heavy shadows.

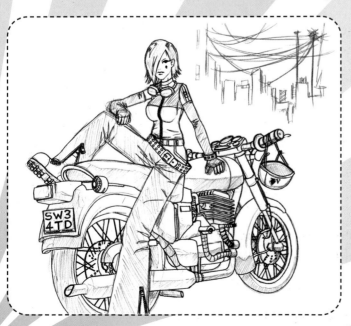

◀ Sketching out the Shadows

Before any more inking is done, shadows are roughly sketched out. Lots of consideration is taken of light sources and shadow-casting, ensuring that the use of light is consistent and solid within the image. Artistic license is taken with certain aspects of the picture, making sure that the detail isn't obscured by shadow and being sure that the outline of shapes is still clear once the heavy shadows are placed.

You can also see the suggestion of a background sketched in at this stage. This is designed to balance the picture and give the bike some sort of location.

Blocking in the Shading ▶

Paying attention to the original lineart, solid black shadows are added to the picture. Two pens are used to block out the black areas of the image; a 1.0 fineliner for detailed areas, and a much larger marker pen for the large areas. For large areas of shadow the smaller pen was used firstly on the outside of the shadow area, with the large pen only used for filling in afterwards. This is to ensure the edge of the shadows is as crisp and clear as the line art itself, and to maintain absolute control.

Finished Image ▼

Once the rest of the image is ready, the background gets filled in with black, and the background detail is inked in. Although some of the finer outline details are obscured with the introduction of a heavy black outline, it's still very apparent that the neatness of the line art creates the overall crisp look.

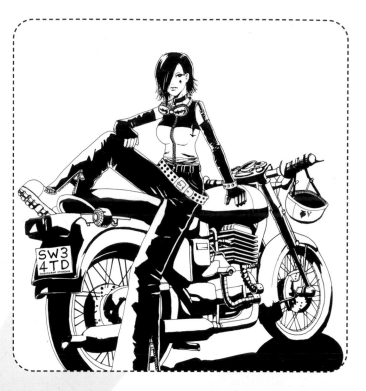

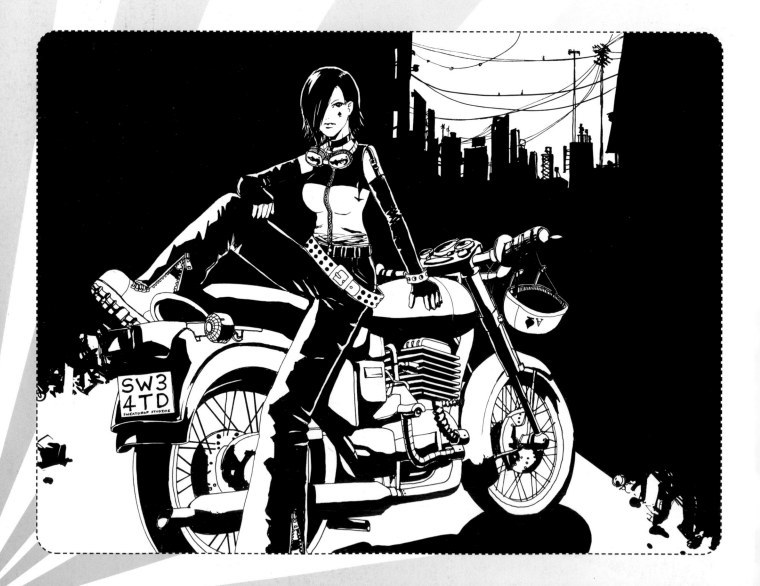

Pen and Ink Alternative

Unlike the main inking piece, this image has been created with very simple lines leaving it open for colouring. The focus in this piece lies in creating clean, yet expressive linework that is easy to fill and colour, so it is left in pure outlines.

Simply sketch the characters in pencil until you are satisfied. Then at the inking stage, rather than inking on the same paper over the pencils, try placing tracing paper on top of your pencil drawing and use this as your inking surface. Keep it in place with paper clips. Use a fineliner for the small details of the faces – this means you can draw details in neatly. To add life and movement, use a brush pen for the rest of the picture to produce natural lines with varied widths.

The result is an incredibly smooth, black finish which is ideal for copying or scanning, and there's no pencil work to remove. The only risk in using this method is that ink may take longer than usual to dry on tracing paper, so position your hands carefully whilst inking to avoid smudging.

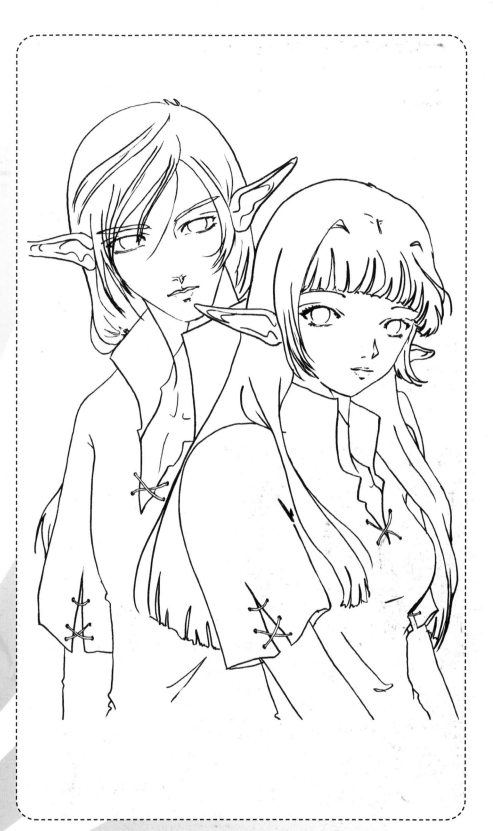

Index